RUTLAND

THROUGH TIME

Stephen Butt

AMBERLEY PUBLISHING

Acknowledgments

I would like to thank Lorraine Cornwall, Collections Manager, Rutland County Museum, for making the Jack Hart Collection accessible to me, and for her valuable and patient assistance. I must also acknowledge the assistance of Darryl Toerien and Roger Blackmore at Oakham School, not only for their provision of archive images but also for guiding me around the school's fascinating buildings. Last – and certainly not least – my thanks to the many residents and landowners of Rutland, who have guided me during the compilation of this book. From Seaton to Braunston-in-Rutland, from Barrowden to Exton, villagers have given their time willingly and enthusiastically. Many have invited me into their homes to look at family photographs, or have taken me on impromptu guided walks of their villages. They have proven beyond doubt the truth of Rutland's motto *Multum In Parvo* – 'much in little'.

First published 2010

Amberley Publishing Plc
Cirencester Road, Chalford,
Stroud, Gloucestershire, GL6 8PE

www.amberley-books.com

Copyright © Stephen Butt, 2010

The right of Stephen Butt to be identified as the Author of this work has been asserted in accordance with the Copyrights, Designs and Patents Act 1988.

ISBN 978 1 84868 901 5

British Library Cataloguing in Publication Data. A catalogue record for this book is available from the British Library.

Typeset in 9.5pt on 12pt Celeste.
Typesetting by Amberley Publishing.
Printed in the UK.

Introduction

Rutland is the very heart of England. It is England's smallest historic county and its smallest unitary authority, except for the City of London. A patchwork of incredibly picturesque and peaceful villages, it is less than twenty miles from north to south or east to west.

At its centre is Rutland Water, by surface area the largest reservoir in the country, covering more than 3,000 acres of land. Formerly known as Empingham Reservoir, this massive engineering project changed the landscape of the county and the way of life of many of its inhabitants. It has matured over the past thirty years into a sanctuary for wildlife and a major tourist attraction, breathing new life into many estates and villages.

Rutland lost its status as a county in 1974 under the 1972 Local Government Act, becoming part of Leicestershire, but its strong identity survived. In 1997, Rutland regained its unitary status and the right to manage its own affairs.

The sepia images have been selected mainly from the Jack Hart Collection in Rutland County Museum. This collection was purchased in 2002 with the help of grants and the Friends of Rutland County Museum. It is a unique collection of over 2,000 images, built up over a period of many years, reflecting life in Rutland over the first sixty years of the twentieth century.

Rutland County Museum is a perfect introduction to the county. The riding school, where the main hall of the museum is housed, was built in 1794/95 for the Rutland Fencible Cavalry, and the museum's original collections were those transferred to it when it was set up by the former Rutland County Council in 1967. These were the rural life collection of Mr E.G. Bolton of Casterton Secondary Modern School and the mainly archaeological collection of Oakham School.

The museum has an extensive rural life collection that includes farm tools, tractors, wagons, and a wide range of rural tradesmen's tools. Domestic and social history is also on display, along with a large collection of archaeological material found in Rutland.

The Local Studies library is also housed within the Museum. Resources include a collection of publications – both popular and academic – on different aspects of Rutland's history.

The Jack Hart Collection comprises a rich resource of topographical images, including street scenes, churches, and manor houses, and there are many illustrations of the county's social history showing aspects of life from the Edwardian period onward.

Together with photographs of the same locations today, these images invite the reader to enjoy, explore, and value the unique charm and the long history of this special part of England.

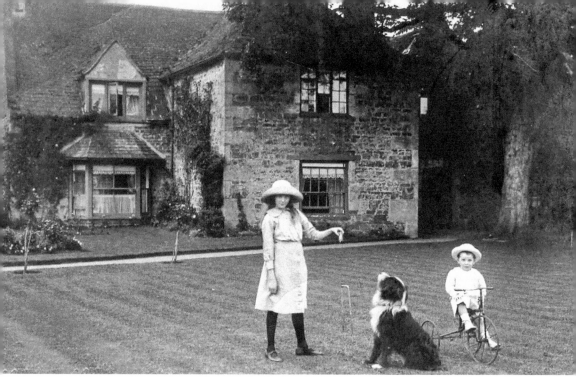

Barleythorpe Manor

This charming photograph was taken in 1915. Heavy traffic intruded on Barleythorpe's peace and quiet throughout the twentieth century, but the opening of the Oakham bypass in 2007 has redirected most of it. Barleythorpe Manor, with its secluded garden, has now returned to the tranquillity of an earlier time.

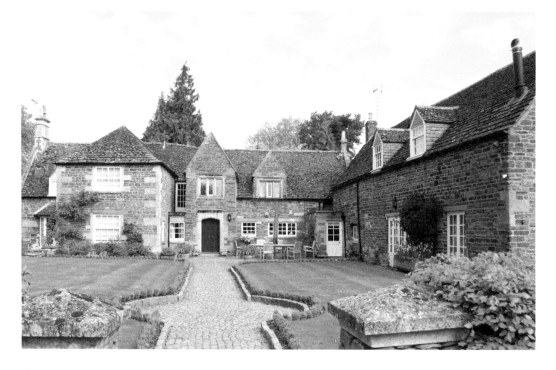

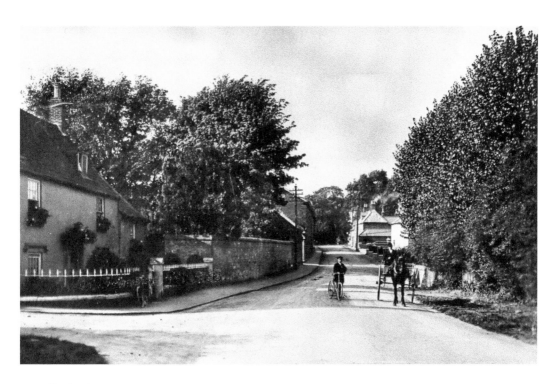

Barleythorpe

Despite being close to Oakham, Barleythorpe has managed to retain its own character. Hugh Cecil Lowther, the 5th Lord Lonsdale, lived here. He gave the original Lonsdale Belt to boxing, and served as Master of the Quorn Hunt. He was known as the Yellow Earl because of his penchant for that colour. He founded and was the first president of the Automobile Association, which adopted his livery.

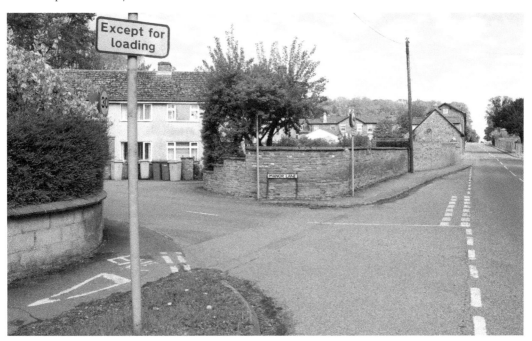

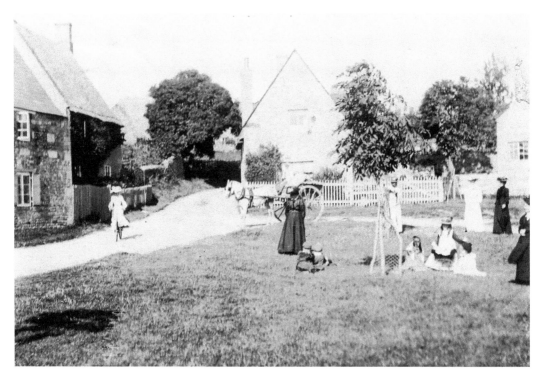

Barrowden

To the north-east of this pretty village are burial mounds, possibly the barrows of Barrowden. At its centre are many mature chestnut trees, which stand on the extensive village green. In 1349, Barrowden was of sufficient importance to have its own market and fair.

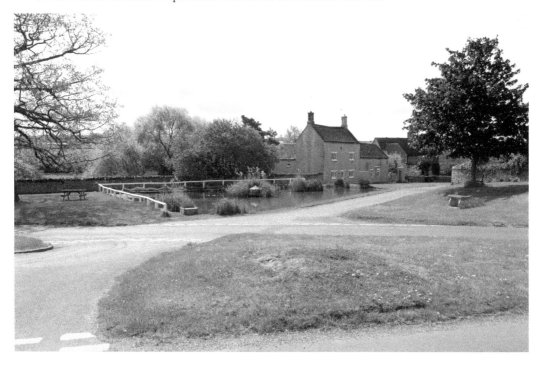

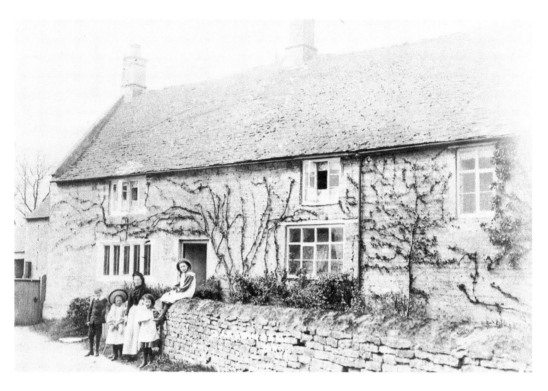

Church Lane, Barrowden

Barrowden has Saxon roots. Set in the Welland Valley, it is the most south-easterly village in the County. Near the entrance to the churchyard of St Peter's is a stone referring perhaps to the passing of funerals: 'Why looks thou on my dust in passing by, thou seest noe wonder thou thyselfe must die.'

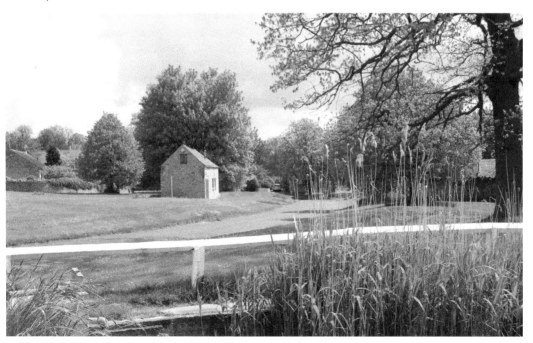

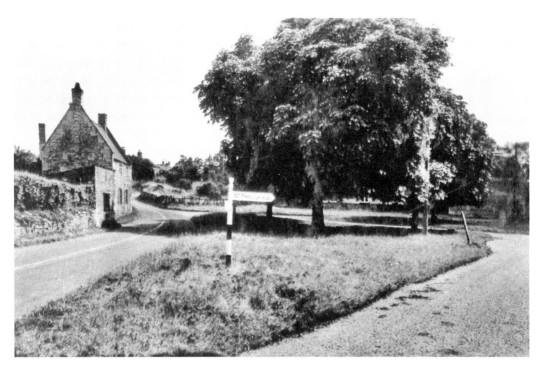

Chestnut Green, Barrowden

In 1833, Marriane Mason, the daughter of a farmer living at West Farm in Barrowden, married Thomas Cook, an itinerant Baptist missionary. They moved to Market Harborough in Leicestershire and in 1841 he hired a special train to take Temperance supporters to a rally in Loughborough. This event was the foundation of the Thomas Cook travel agency.

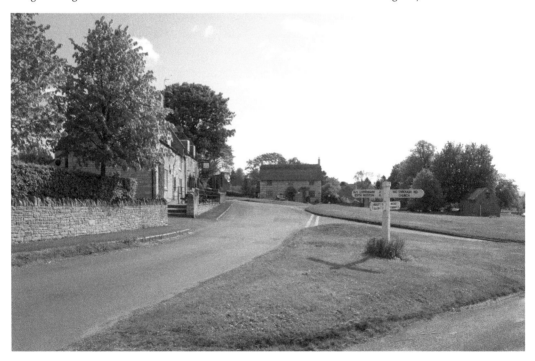

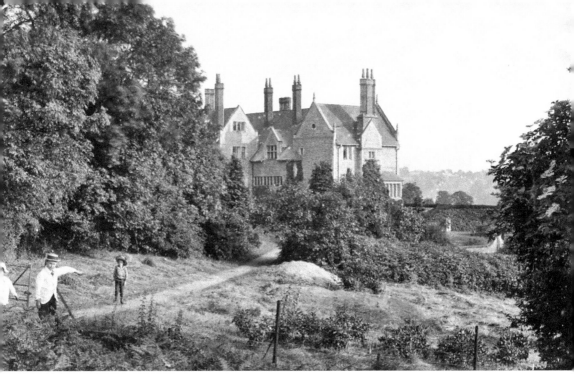

Barnsdale Hall

A dignified building, Barnsdale Hall stands high above the picturesque northern shore of Rutland Water with breathtaking views cross the Vales of Catmose and Gwash. The original Grade II listed building was constructed as a hunting lodge in 1890 for the Earl Fitzwilliam. When the hall was built, Rutland Water was a fertile valley. The reservoir was created eighty years later.

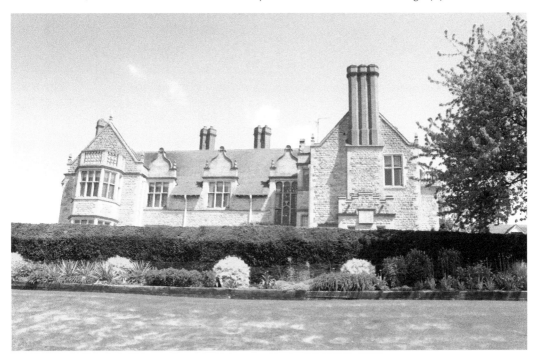

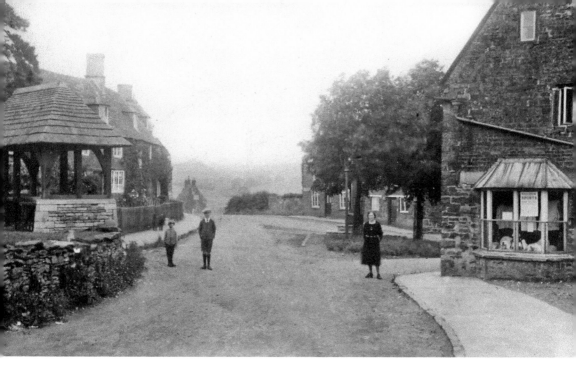

Church Street, Belton

Belton-in-Rutland stands at the foot of Wardley Hill, the gateway to Rutland from the city of Leicester. To mark the Feast of St James the Apostle, a fair and a circus were held every year at the top of Goughs Lane in the village from 1330 until the First World War.

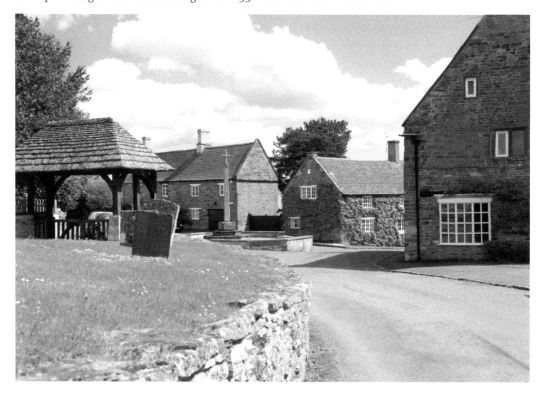

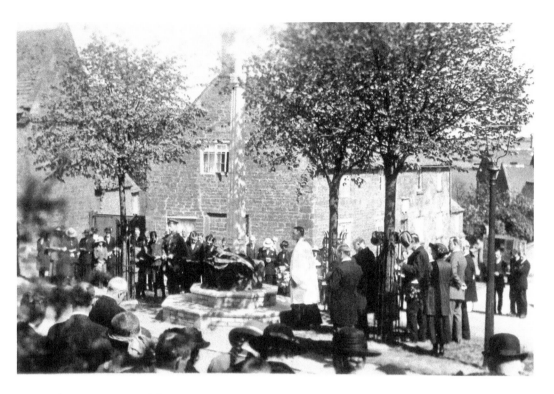

Belton War Memorial

It is said that Charles I rested here in Belton after the Battle of Naseby in 1645, which was over twenty miles distant in Northamptonshire. The stone base of the war memorial is still known as the King's Stone.

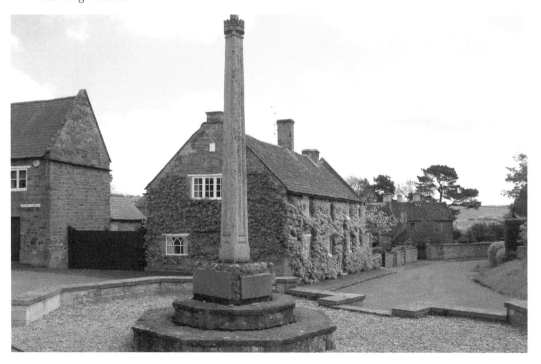

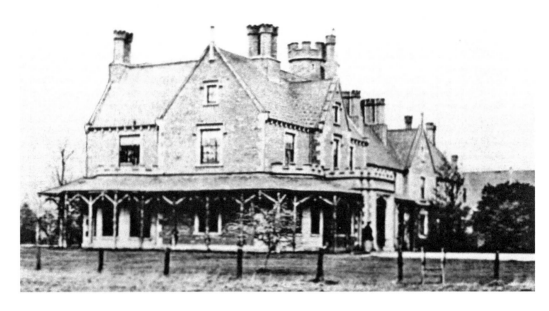

Bisbrooke Hall

The hall stands in a peaceful park location surrounded by mature trees. The oldest part dates from about 1740 and it is the second house to be built on the site. In 1840, Lord Carbery renovated the house and in the 1960s further alterations included the former brew house and laundry being turned into a baronial hall by Mr. George Boyle, whose descendents live there today.

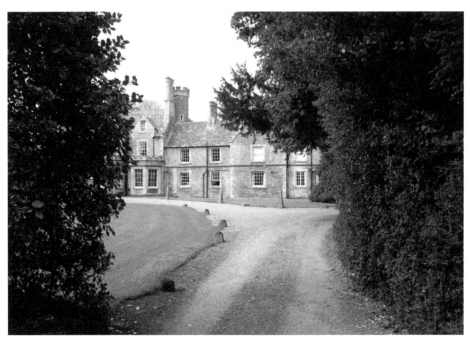

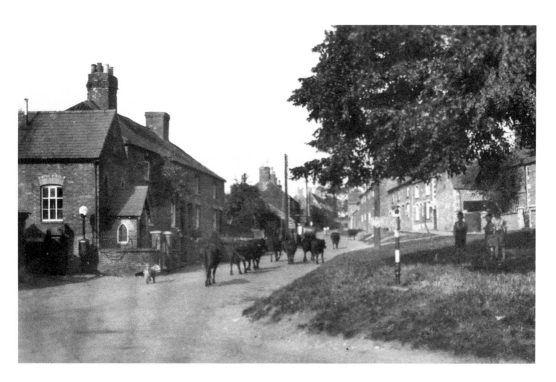

Braunston-in-Rutland (I)

In this photograph, taken just before the First World War, there is all the time in the world for the cattle to amble past the village petrol pump and the little chapel, which was built in 1868. Today, this is a busy route for traffic *en route* between Oakham and Leicester.

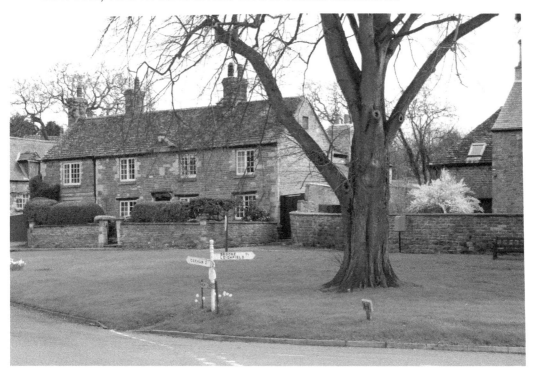

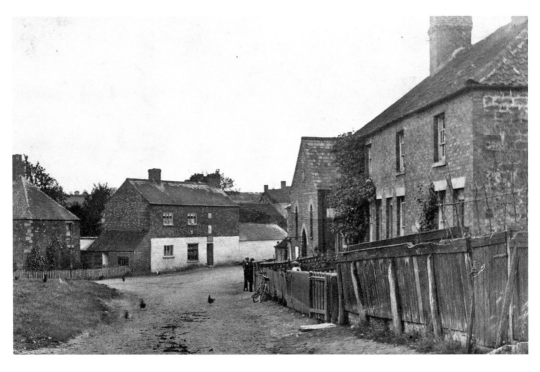

Braunston-in-Rutland (II)

Among the fine houses and cottages that are set back along the High Street are some very early structures. One building includes masonry removed from an earlier church.

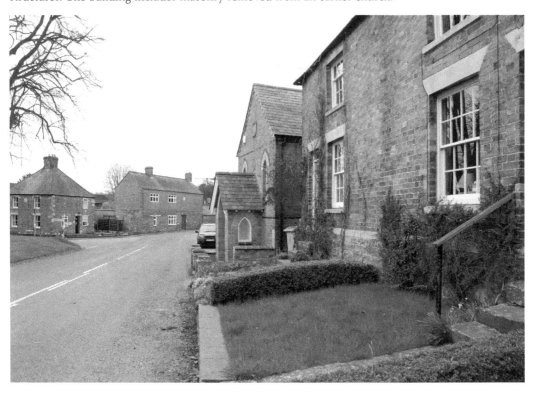

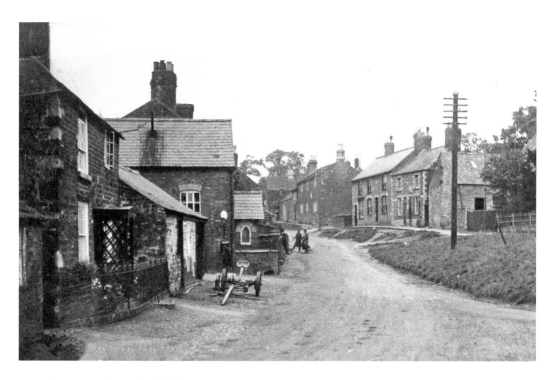

Braunston-in-Rutland (III)

In the churchyard at the west end of the church stands an unusual sculpted stone known as the Braunston Goddess. It was found in about 1920 when the church doorstep was being replaced. When the slab was lifted, carving was revealed on the underside. There has been considerable debate as to its age and meaning, and whether or not it predates the church.

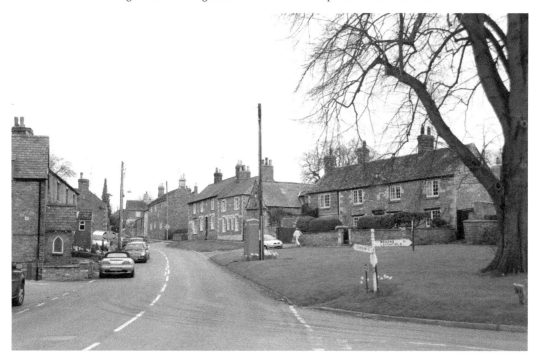

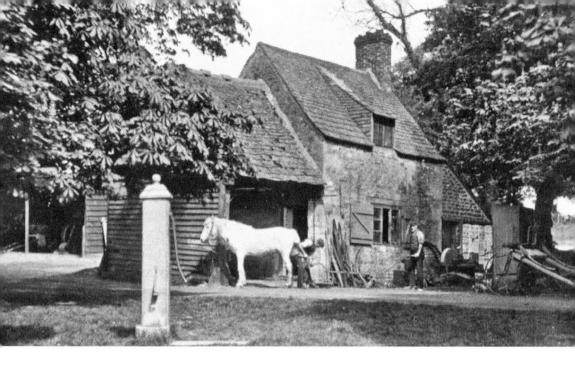

Burley Smithy

The old smithy on the village green in Burley in 1904. The building was used in advertisements for Cherry Blossom shoe polish in the 1920s. Burley is one of Rutland's most picturesque hamlets, boasting the 'spreading chestnut-tree' made famous in Henry Wadsworth Longfellow's poem, 'The Village Blacksmith'.

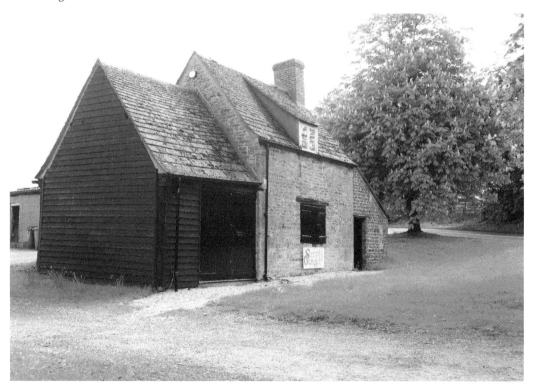

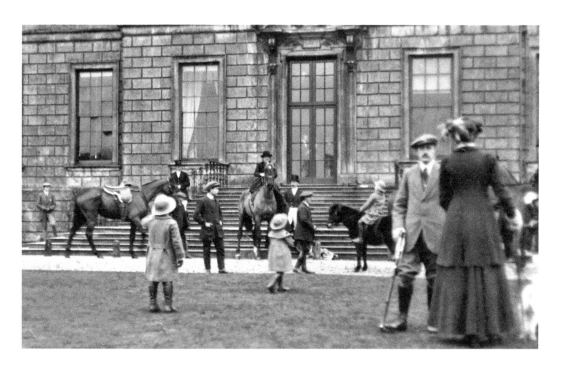

Burley-on-the-Hill

The hunt gathers in front of the impressive façade of Burley-on-the Hill. Joss Hanbury of Burley-on-the-Hill was one of the most popular masters of both the Cottesmore and the Quorn. The building that once stood on this site witnessed great banquets and masques and at least one theatrical visit by the Lord Chamberlain's Men featuring William Shakespeare. During the First World War, Burley was a recuperation centre for officers. Later it housed an orthopaedic clinic, run by the formidable Miss Goodband, who 'encouraged' diabetic patients to take regular walks into Oakham where they would take tea at 'Greasy Joe's' café. She was awarded an OBE and buried in the village cemetery.

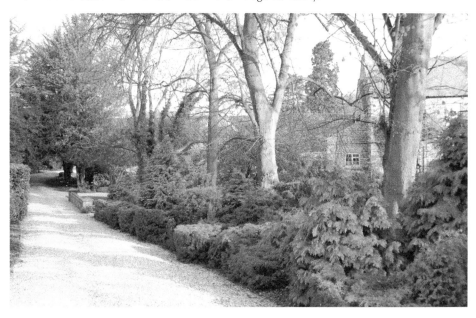

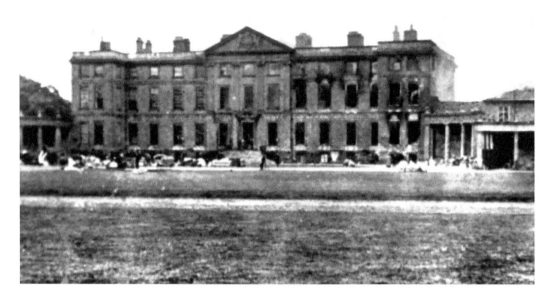

The Burley-on-the-Hill Fire

In 1908, a great fire swept through the west wing and ballroom at Burley. Captain Freddie Guest, who had rented the property from the Finch family, had to summon the Oakham fire brigade. The house party included Winston Churchill, whose flapping dressing gown was helpfully pinned together by a nail presented by a local farmer. In 2001 the building was used for the filming of period melodrama *The Four Feathers*. Today, its extensive grounds are the home of the annual Rutland County Show.

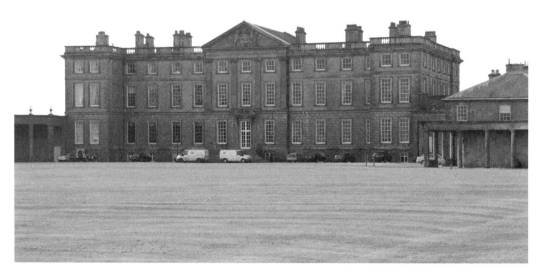

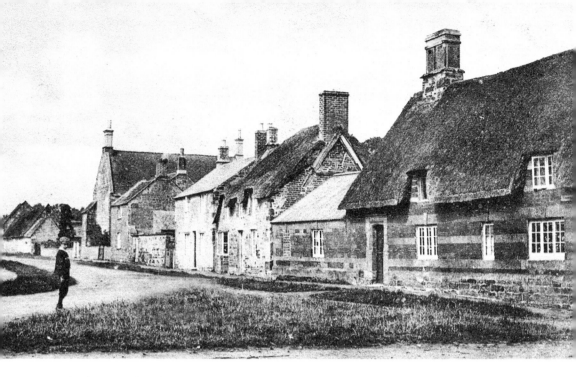

This is a view along the road towards Uppingham, taken from the junction with the Lyddington Road. Many of the cottages are built with local Welland sandstone, which has a characteristically warm colour.

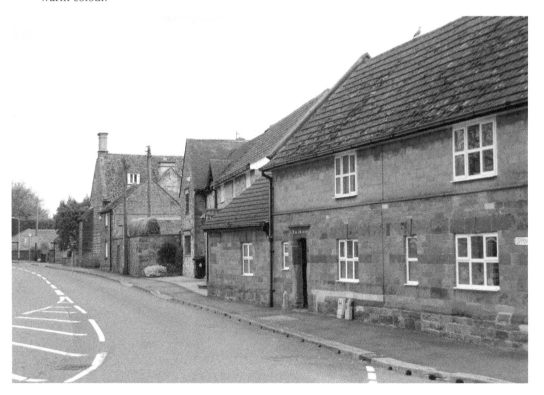

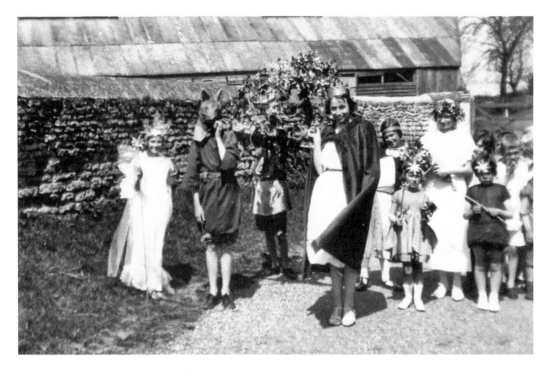

May Day Celebrations, Caldecott

May Day was celebrated in style in many Rutland villages, and some had their own unique traditions. The coming of Christianity to Europe meant that earlier pagan traditions became either secular or vaguely Christian, or a curious mix of the two – connecting the maypole on the village green to the parish church. These young people were photographed in 1936. They would have attended their local school, which was built in 1878, but today 's youngster's travel to the schools in the larger neighbouring villages.

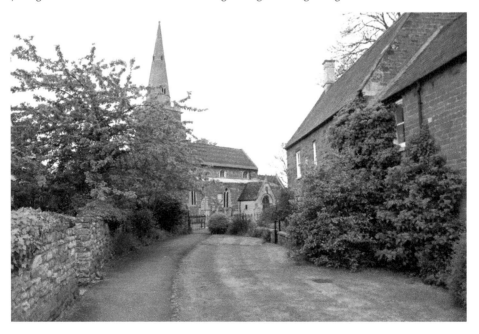

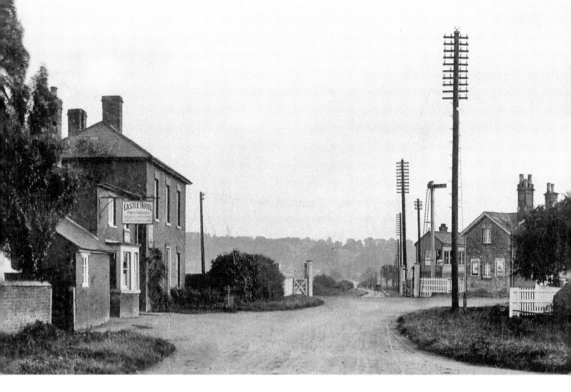

Rockingham Railway Station, Caldecott, in 1922

Caldecott's railway station closed in 1966. It also served the larger neighbouring village of Rockingham, hence the name. The Castle Inn is still open, but as the red van indicates, the post is now brought to the area by road and not rail. Caldecott is the most southerly village in the county. Although the photographer is standing in Rutland, the landscape beyond the railway crossing is in Northamptonshire.

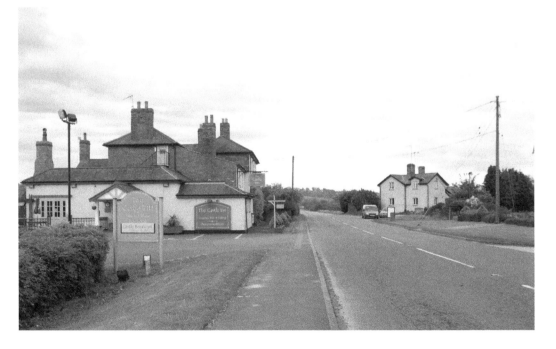

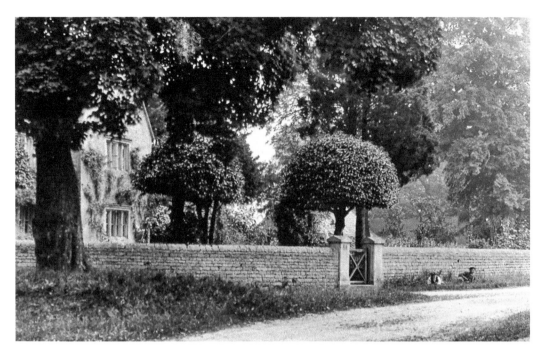

Clipsham Manor House

One wonders if the occupants of the Manor House knew that just outside, under the shelter of the wall, two wily estate workers were taking a break from their labours! The front gate and path from the main road through Clipsham has been filled in since this photograph was taken in 1919.

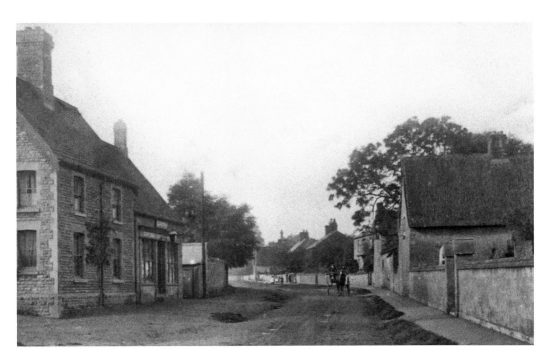

Cottesmore Shops

Apart from the mode of transport, very little has changed in the centre of Cottesmore for almost a century. The shop on the left in the earlier photograph is now the village chip shop! Cottesmore is the third largest settlement in Rutland after the towns of Oakham and Uppingham, and it gives its name to the county's Cottesmore Hunt. The foxhounds arrived in the village in 1740.

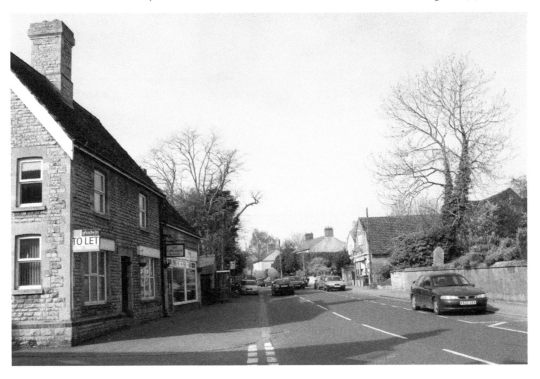

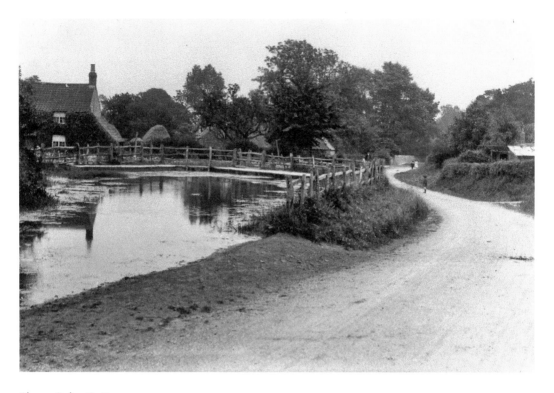

Sheep Dyke, Cottesmore

The sheep dyke survives into the twenty-first century in the name of a small lane leading to a cluster of cottages on the edge of the village. The structure was a vital part of the management of the land, keeping sheep away from areas under cultivation.

RAF Cottesmore

On 11 March 1938, the quiet village of Cottesmore acquired new neighbours when RAF Cottesmore opened. Bombing trials flew out of Cottesmore later that year. Many of the village's facilities, including shops and the village school, have depended on the support of RAF personnel and their families for more than half a century. In 2010, the Government announced plans to close the base.

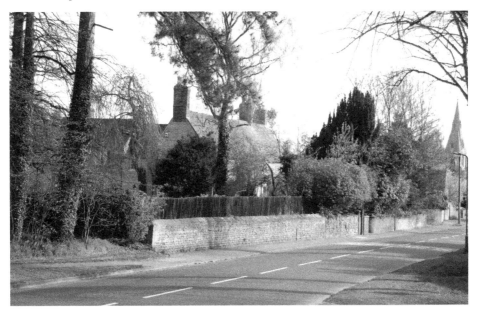

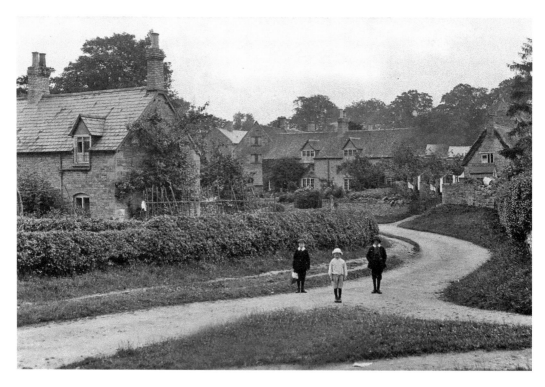

Edith Weston (I)

Children stand at the approach to Edith Weston from Gibbet Lane. Close by is now the southern shore of Rutland Water. The village is named after Queen Edith of Wessex, the wife of Edward the Confessor, and sister of Harold Godwinson. She received the village as a gift from her husband. King Edward's Way – the street name is modern – is close by.

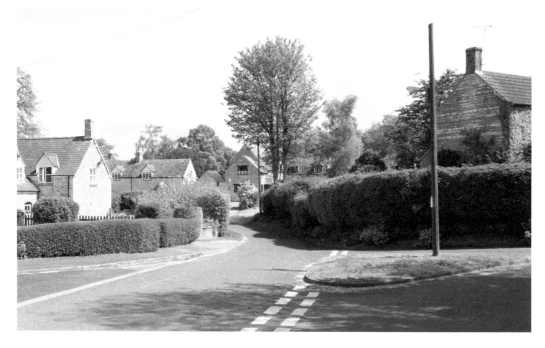

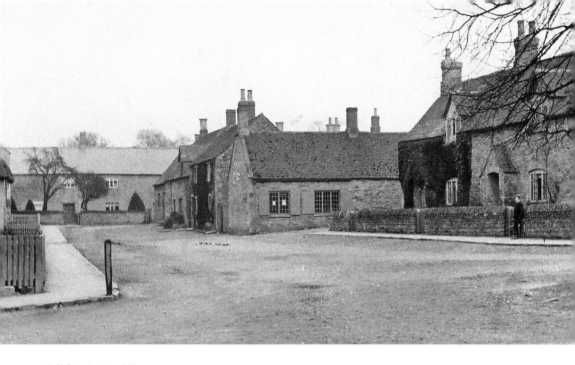

Edith Weston (II)

Typically, at the heart of the rural community stood the forge. Here in Edith Weston, the building remains, in the very centre of the village.

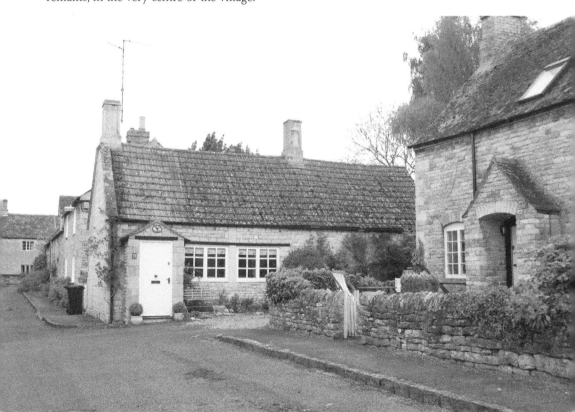

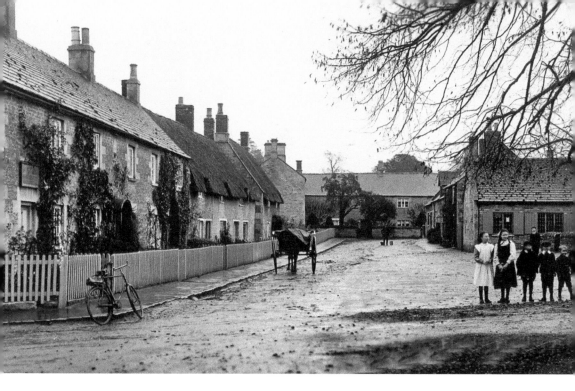

Edith Weston (III)

Benedictine monks occupied a small cell here at Edith Weston from the twelfth century to the end of the fourteenth. It is documented that their far-from-Christian behaviour caused many hardships for the villagers.

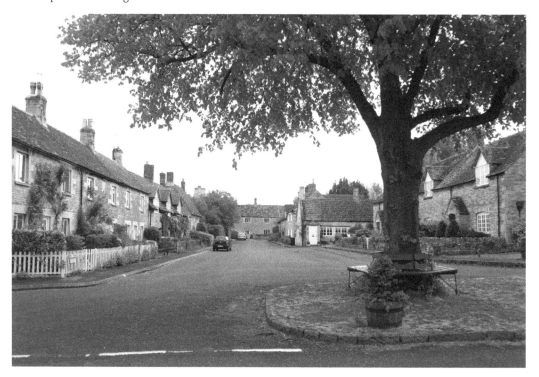

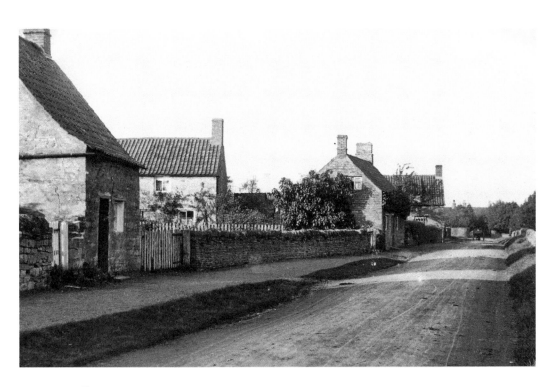

Essendine

Essendine has about it the air of eastern England. The crops in the surrounding fields – wheat, barley, sugar beet, and potatoes – are typical of this area of the country. The village lies on the River Glen at the eastern edge of the county.

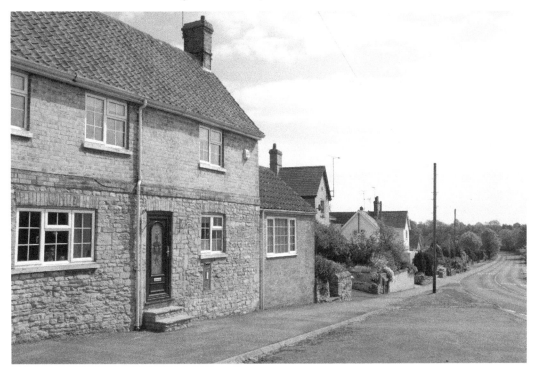

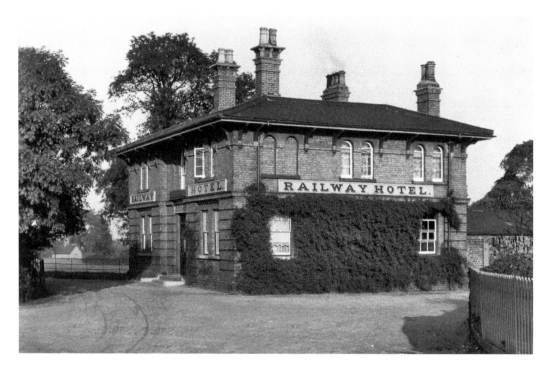

Railway Hotel, Essendine

The railway line through Essendine was laid out in 1852 and became the East Coast Main Line. In 1938, the LNER steam locomotive *Mallard* sped through the station just seconds after breaking the world speed record for steam by achieving 126 mph. The station closed in 1959, but this solid and impressive railway hotel has survived.

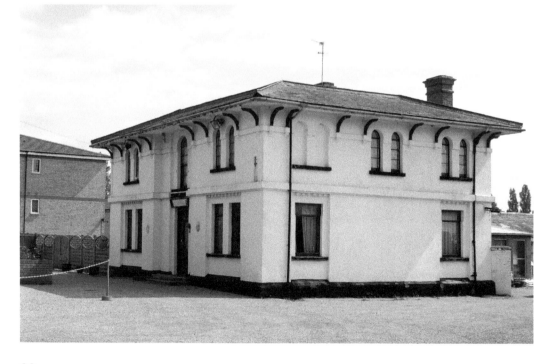

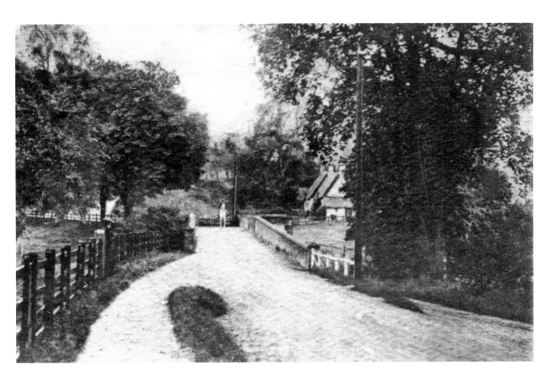

Empingham Bridge

The pack horse bridge at Empingham marks the entrance to the village from Stamford and the Great North Road. Today the road is the busy A606 route linking Stamford with Oakham. The bridge has been suitably widened, and the line of the road has moved. The cottages have changed little since 1913, when the earlier photograph was taken.

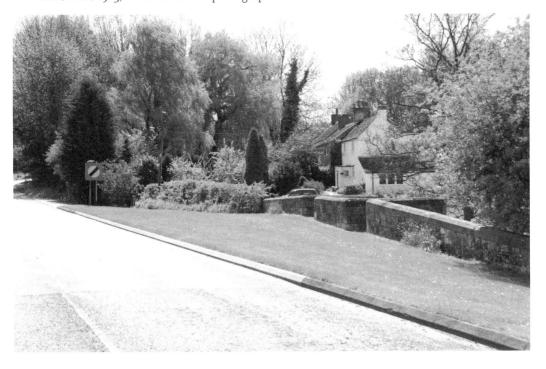

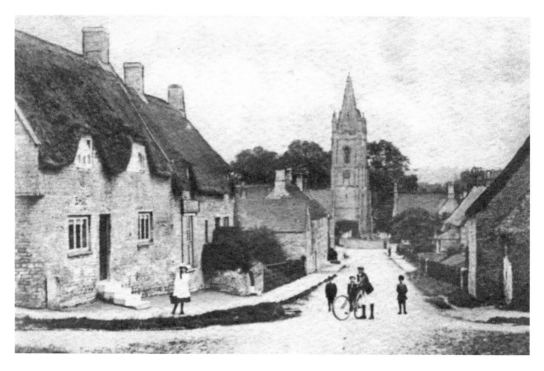

Church Street, Empingham

Exactly 100 years separates these two views of Church Street in Empingham, and yet, apart from a television aerial and a few cars, the scene has changed remarkably little. The parish church of St Peter stands on high ground. Its fourteenth-century tower and spire dominate the landscape for miles around.

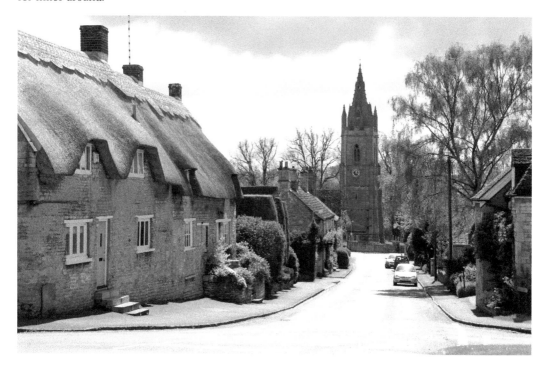

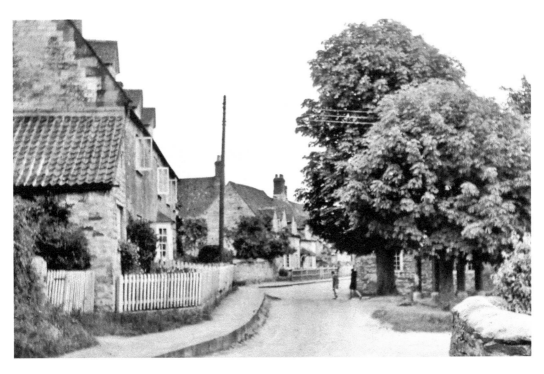

Exton (1)

The village of Exton stands detached, some miles west of the Great North Road and a mile or so north of Rutland Water. The town pump can be seen behind the trees in both photographs, standing at the junction of Top Street and High Street.

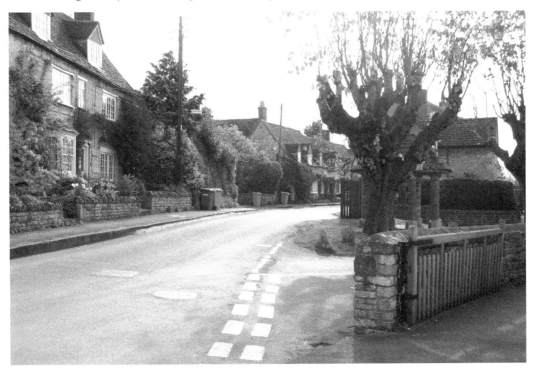

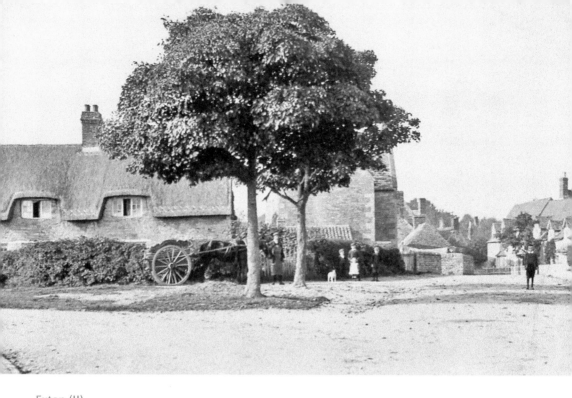

Exton (II)

In the past, Exton has been dominated by the influence of the surrounding estate. Exton Park has been the home of the Noel family (the Earls of Gainsborough) for nearly four centuries. The park has existed since the twelfth century. Today, the village still has a sense of its agricultural past.

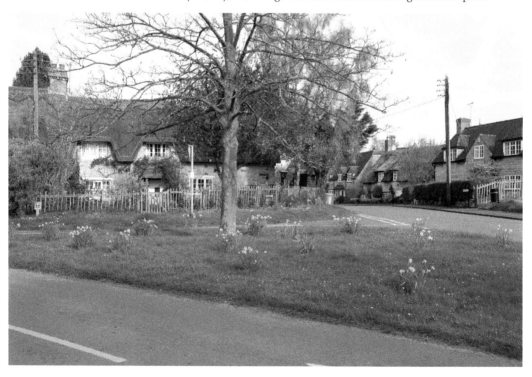

Glaston (1)

Thousands of vehicles pass Glaston every day, as it lies on the main trunk route between Leicester and Stamford and the A1 Great North Road; but away from the tarmac is a quiet and incredibly quaint village.

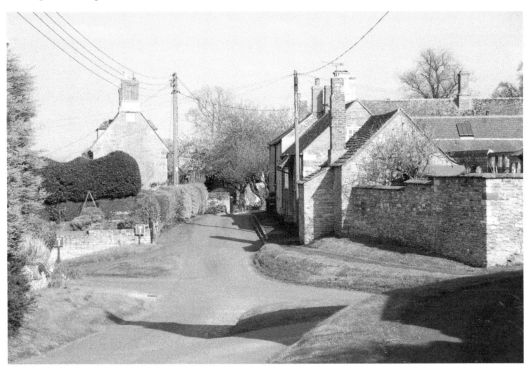

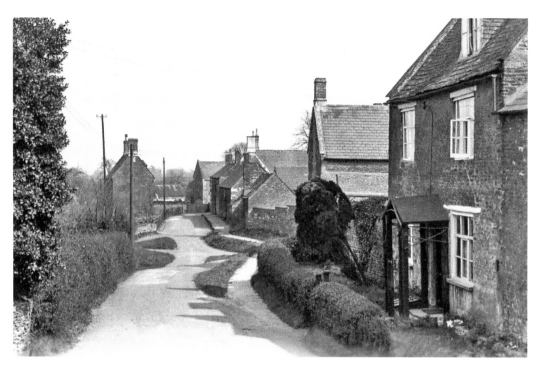

Glaston (II)

Important archaeological finds were discovered near the village of Glaston in recent years. Whilst excavating a medieval site, much earlier remains were uncovered, which have not only shed new light on the very earliest inhabitants of this area but will act as a guide to identifying similar sites in the future.

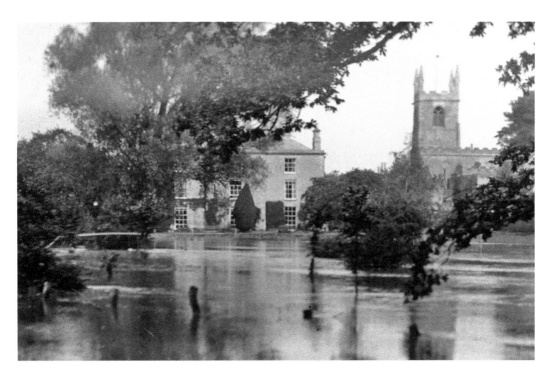

Great Casterton Floods

Great Casterton is on Ermine Street, the Roman route to the north through this part of the country. It appears that even Roman civil engineers had problems with the flooding in the area. Possibly, they built diversionary roads. The original Roman route runs just to the right of the church. To the left is the brook. This photograph was taken in late summer, on 27 August 1912.

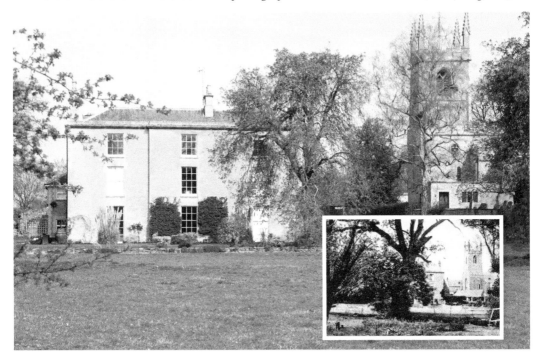

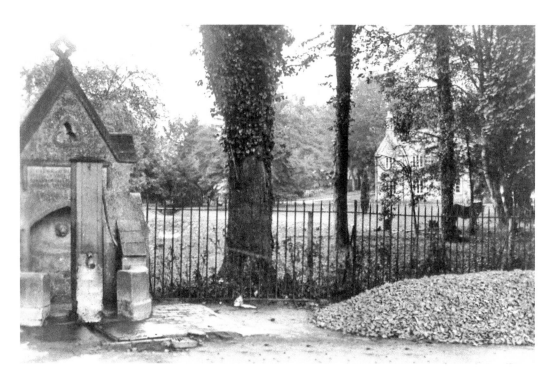

Greetham Village Pump

Tucked away, just a few yards from the main street through Greetham, the village pump survives into the twenty-first century and still proclaims its old message: 'All ye who hither come to drink, rest not your thoughts below. Remember Jacob's Well and think whence living waters flow.'

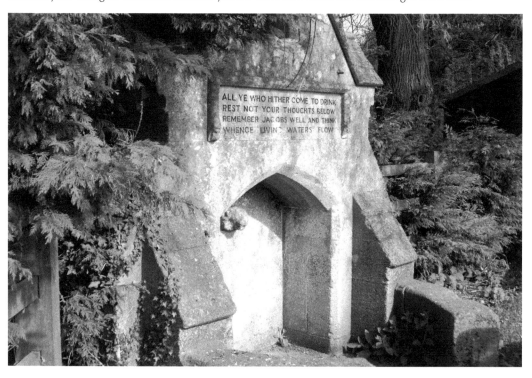

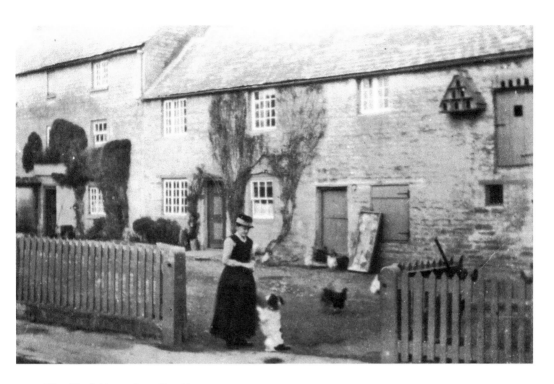

The Black Horse Inn, Greetham

There are three pubs in Greetham, and all lie on the main road from Stretton to Cottesmore. The Black Horse is the establishment that seems to have changed the least.

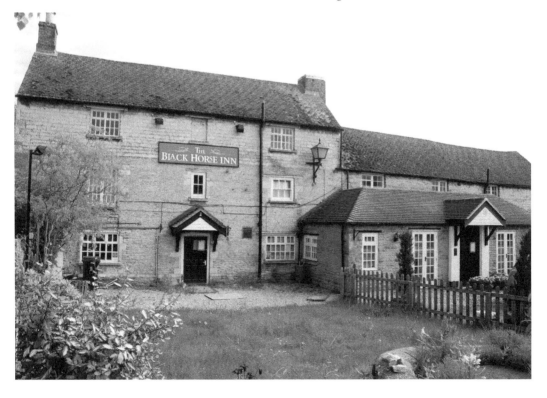

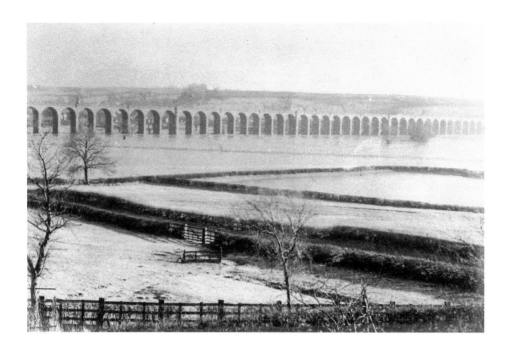

Harringworth Viaduct

This quiet valley of the Welland was turned into an industrial complex for several years when the railway arrived. This viaduct is more than a kilometre in length. It has no less than eighty-two arches, and each arch has a span of twelve metres. It is the longest masonry viaduct in the country, and was was completed in 1878. The railway track is, at its maximum, sixty feet above the valley, which was prone to flooding, as this early photograph clearly demonstrates. This remarkable structure, now an accepted part of Rutland's landscape, has Grade II listed building status and is a favourite for railway enthusiasts' excursions.

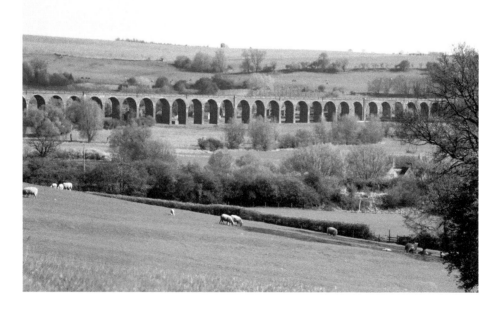

Ketton Post Office

Ketton was originally three separate villages: Ketton, Aldgate, and Geeston. Their gradual amalgamation created a settlement that now ranks as the fourth largest in Rutland. This photograph dates to 1912.

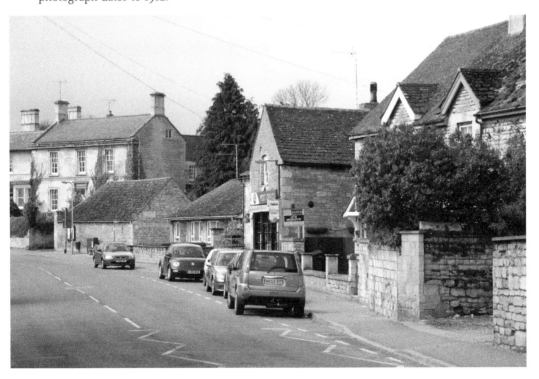

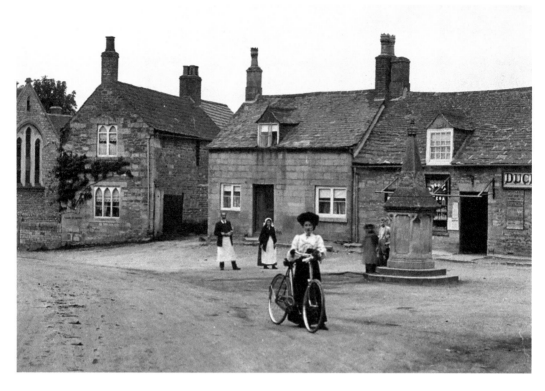

Ketton Cross

Ketton is known worldwide for its limestone, quarried nearby, and in the churchyard are many examples of Ketton stone headstones. The church, in the heart of the village, has a fine broach spire that was added in the fourteenth century. In the shop window are advertisements for Cadbury's Cocoa and Bovril.

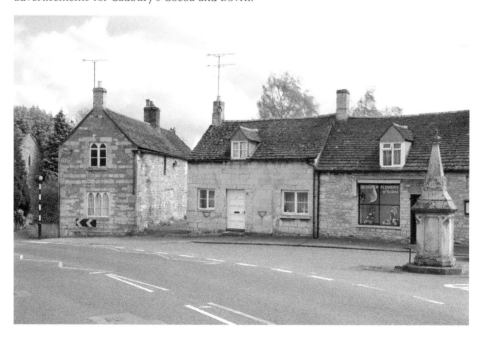

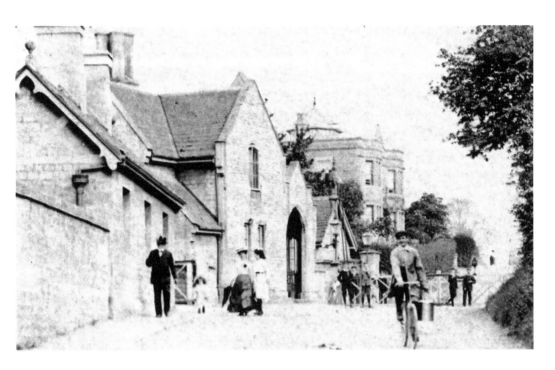

Ketton and Collyweston Station

This is possibly the oldest photograph in this compilation and dates from 1905. The Ketton and Collyweston railway station was built in a Victorian ecclesiastical Tudor pattern of local stone and Collyweston tiles. It opened in 1848 and closed in 1966. An interesting modern residential complex stands on the site today.

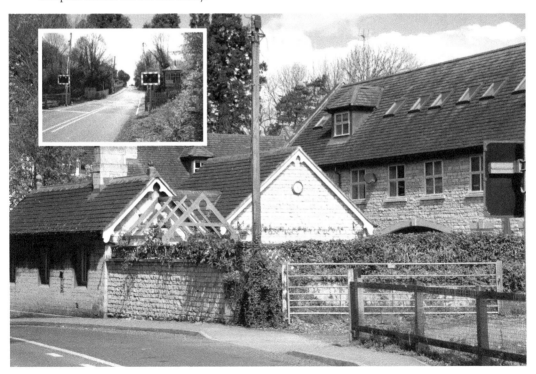

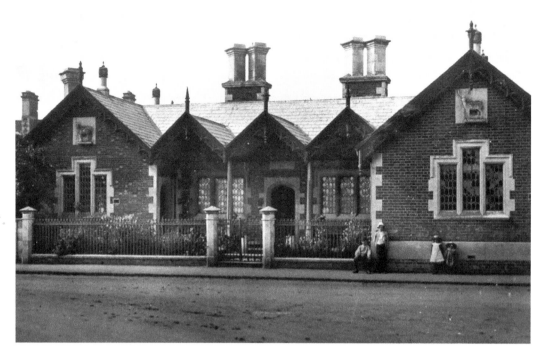

Langham School

Only one part of the old school, which was built in several stages, exists today. It standS directly opposite the present modern and well-equipped primary school. Behind the old building, now a private residence, the small school yard remains.

Langham Church

The village of Langham is probably best known outside the County of Rutland as the former location of the Ruddles Brewery, which began brewing beer here in 1858 and closed in 1999. It is a fascinating village with a long history, which has been recorded very effectively by the local history group.

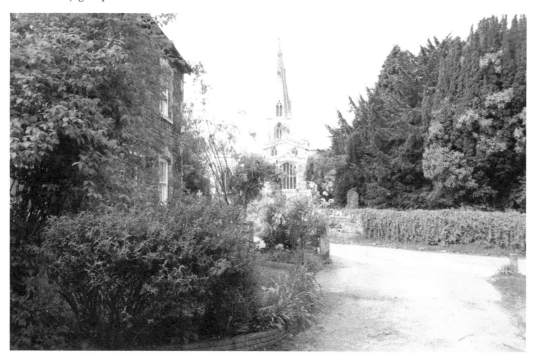

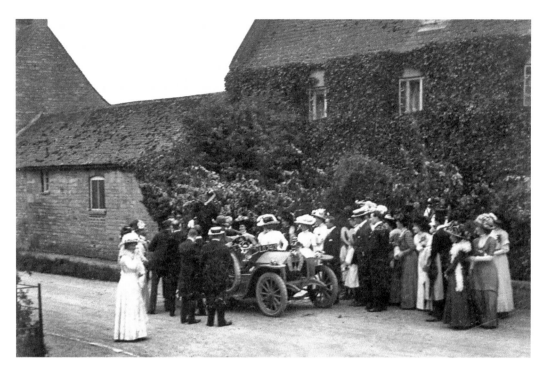

A wedding takes place in Little Casterton. The happy couple are probably about to leave for their honeymoon. If this was the bride's home, then the party had but a short walk to reach All Saints', the parish church.

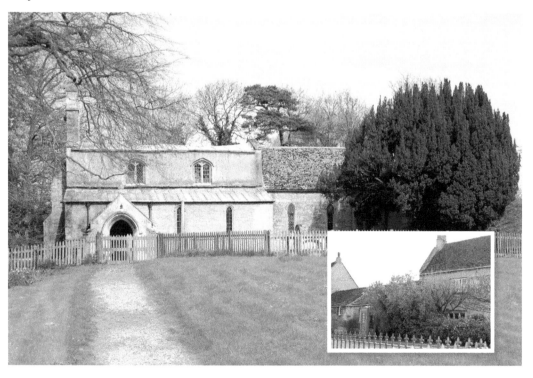

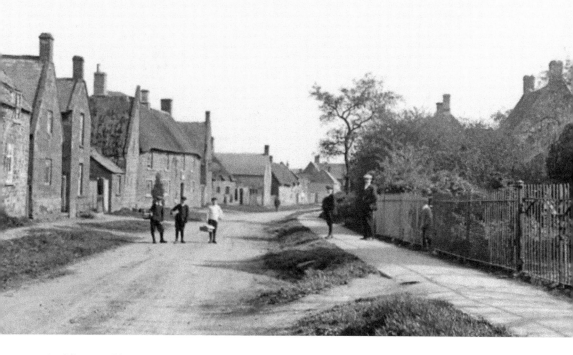

Lyddington (1)

Lyddington is a village of great charm, and the presence of The Bede House gives it a sense of historical significance. Many of the buildings are made of red sandstone, quarried just a mile or so away near Stoke Dry.

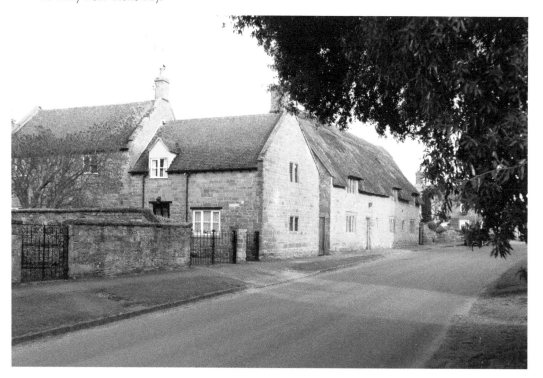

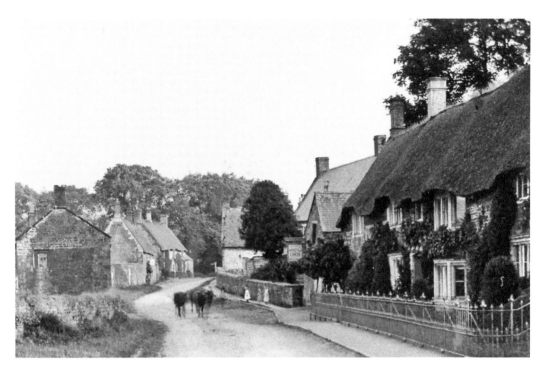

Lyddington (II)

Locally, Lyddington has being referred to as 'long-low, lying-lazy' which certainly describes this photograph from the early twentieth century. Before the turnpike between Uppingham and Caldecott was built, this was a main route. There were no less than five pubs along Main Street.

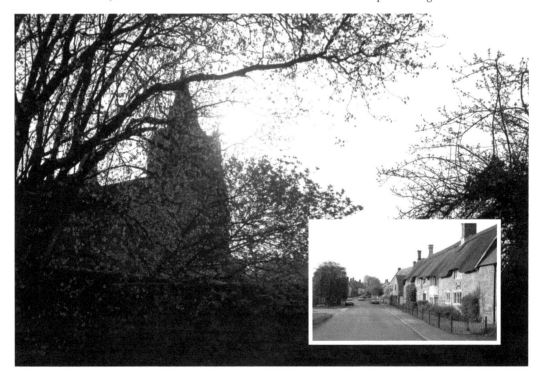

Bede House, Lyddington

This is one of the finest examples of fifteenth-century domestic architecture in the country. It was originally the medieval wing of a palace belonging to the Bishops of Lincoln – the palace's fishponds are in evidence nearby. By 1600, it had passed to Sir Thomas Cecil, the son of Queen Elizabeth's chief minister, who converted it into an almshouse. It is said that Henry VIII and Catherine Howard stayed here while travelling from Lincoln to London. It was last occupied in the early 1930s and is now in the care of English Heritage.

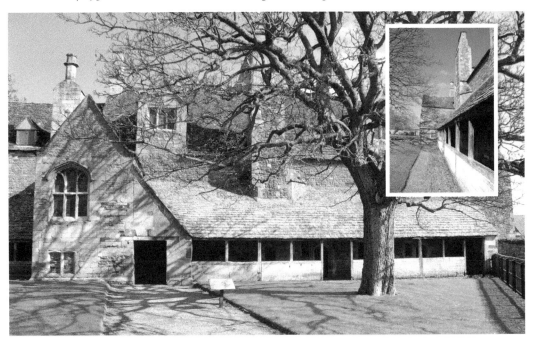

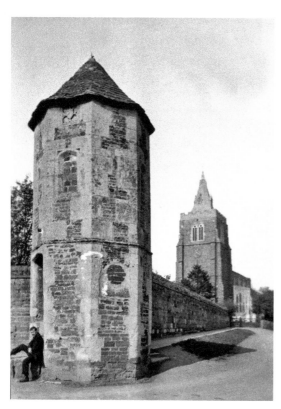

Bishop's Eye, Lyddington
This tower, standing on the corner of Church Lane in the shadow of the very beautiful church of St Andrew, is associated with The Bede House and its surrounding gardens.

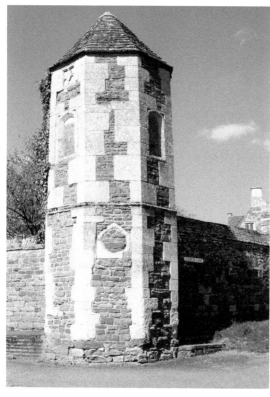

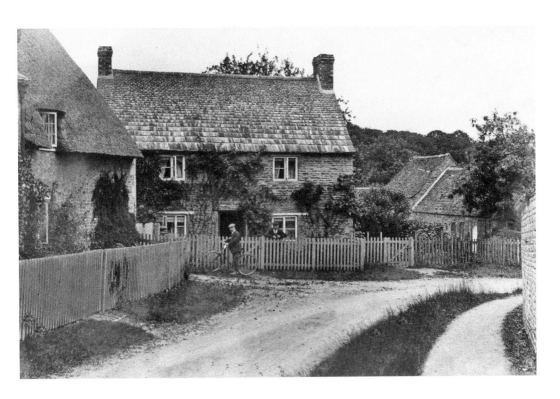

Lyndon (I)

Situated in quiet countryside between Manton and North Luffenham, Lyndon is a small village of great charm which has changed little over the past century. In 1870, there were 126 people living in Lyndon's 27 houses. By 2001, there were just 80 residents

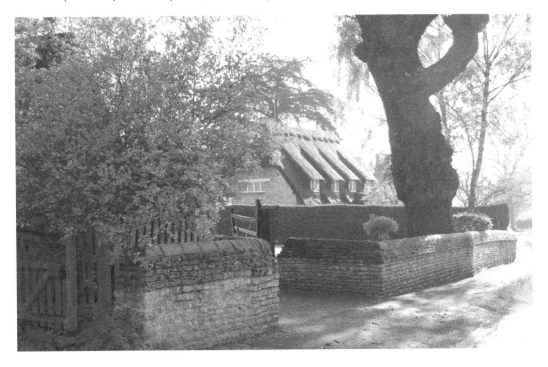

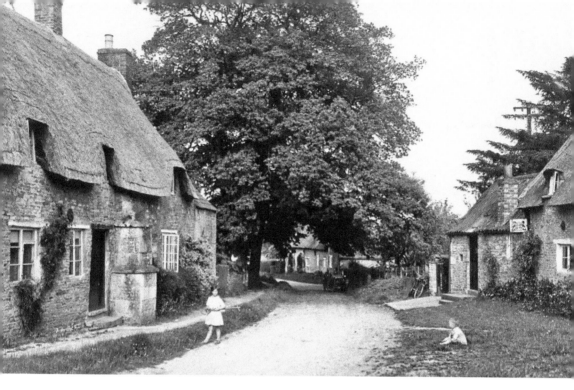

Lyndon (II)

The work of two men –who were related and who both lived at Lyndon Hall – has placed Lyndon on the world map. William Whiston translated the writings of the Jewish historian Josephus, and died at the Hall. Thomas Barker, the eighteenth century meteorologist, kept detailed records of the weather in Lyndon for over sixty years. His family had lived in the village since the time of Henry VIII.

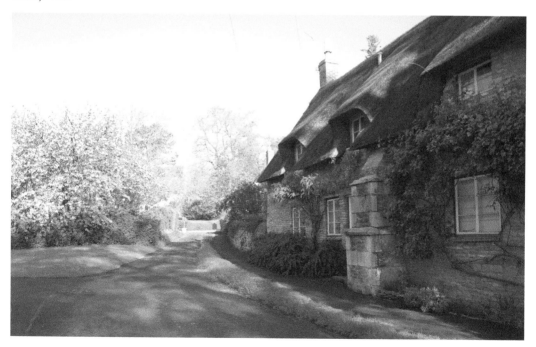

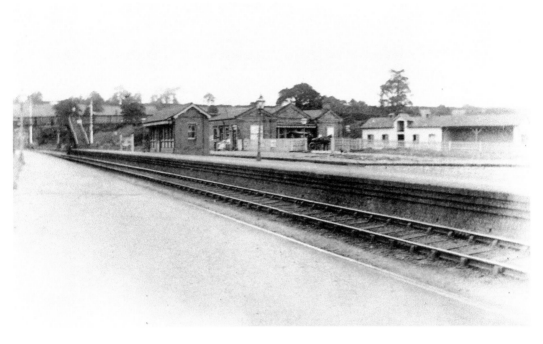

This is a sad and poignant example of the decay that occurs when a building becomes redundant. Manton Station was located a mile from the village, halfway to neighbouring Wing. It was a busy place, serving for some time as a railhead for Uppingham. It closed in 1966, and what remains of the buildings are part of an isolated and seemingly desolate industrial area.

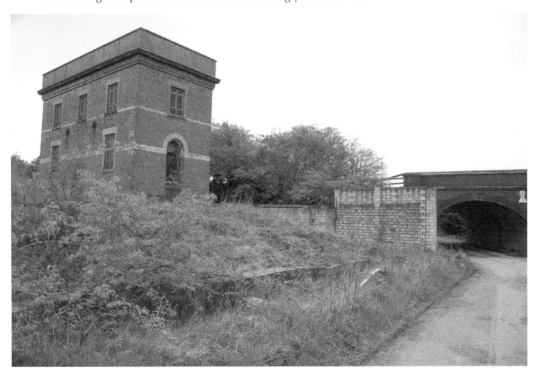

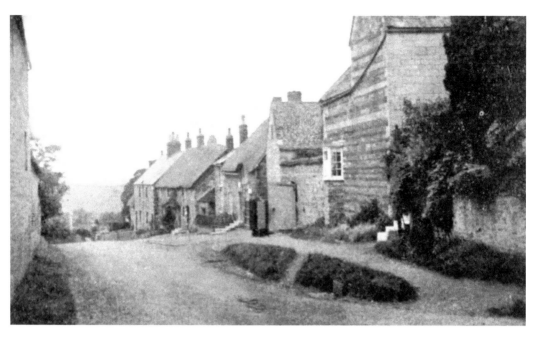

Manton (I)

Manton stands on a ridge between two rivers, Gwash and Chater. The stone cottages, some with ancient mullioned windows, were saved from a disastrous fire that swept through the village in 1732. Thomas Blore, the antiquary and historian of Rutland, lived here for a time.

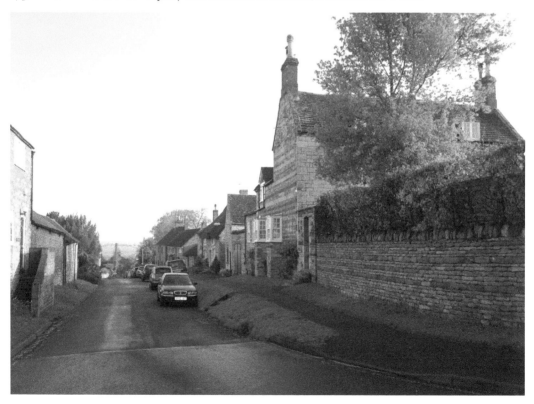

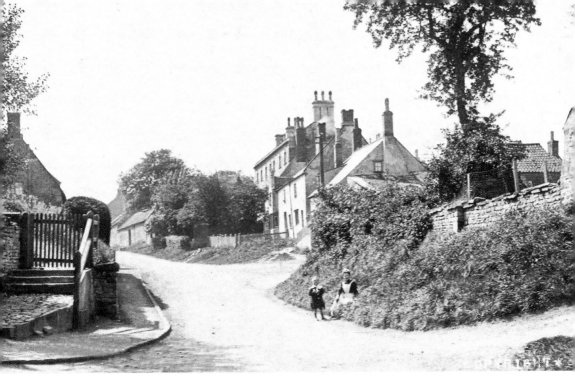

Manton (II)

The parish church of St Mary in Manton stands on high ground at the centre of the village. Its fascinating angles and irregular lines are the result of over 700 years of building, demolition, and rebuilding.

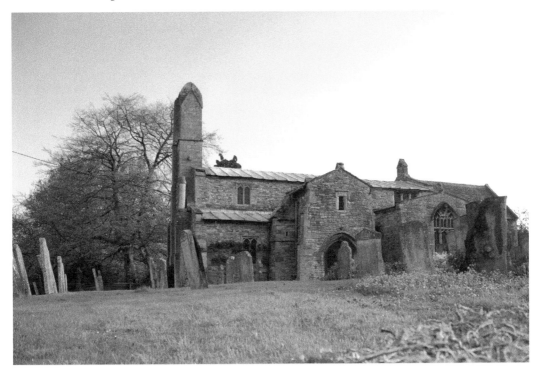

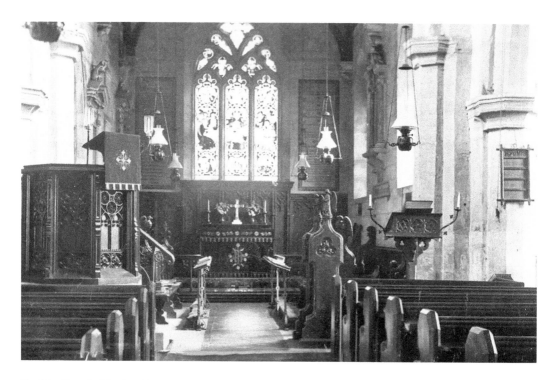

Parish Church, Market Overton

The Parish Church of St Peter and St Paul stands on the site of a Roman camp. At the west end of the church is a Saxon arch, preserved when the pre-Conquest church was demolished. The memorial cross in the foreground is dated 1890. It is said that the ghost of a man in white can be seen if you walk around the church several times.

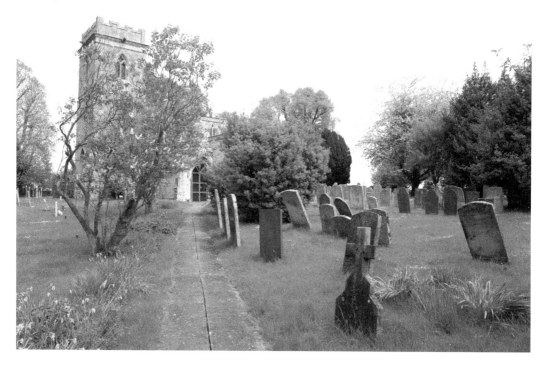

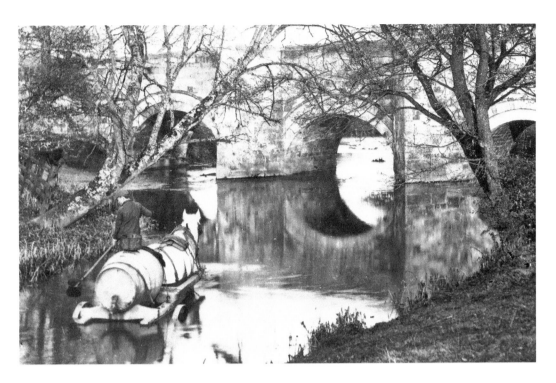

Main Street, Market Overton

The wide sweep of Main Street gives the centre of Market Overton a quiet dignity. There are references to a market in the village from as early as the twelfth century, but the settlement's long history reaches back to the Roman period.

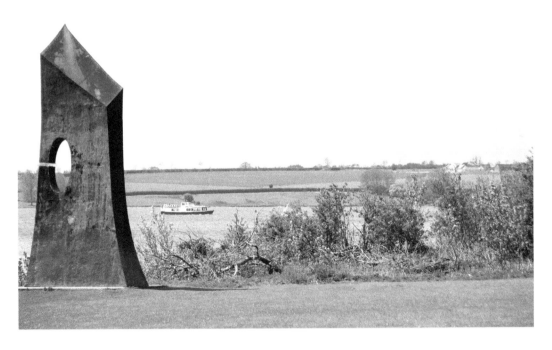

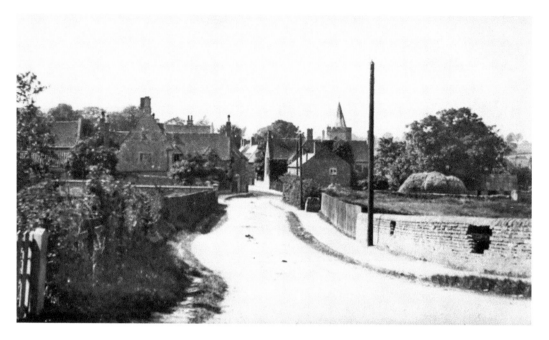

Church Lane, Morcott

Morcott is located on the busy A47 trunk route, which carries traffic between Leicester and Peterborough and the A1, but away from the main road is a typically quiet Rutland village with a church at its heart. The tower is Norman, dating to the early part of the twelfth century. The Morcott windmill, familiar to drivers on the A47, is mentioned in documents written as early as 1489, and has now been restored.

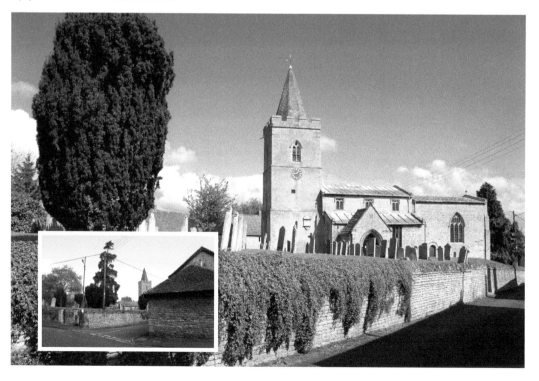

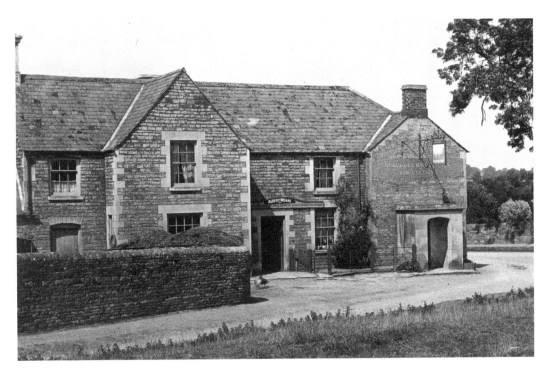

The White Horse Inn, Morcott

As with so many of Rutland's pubs and inns, there is so little change over time. Apart from the chimney pots, the White Horse, situated on the Stamford road, appears just as it was over seventy years ago.

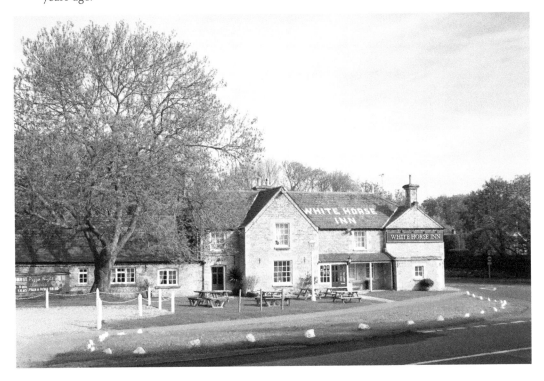

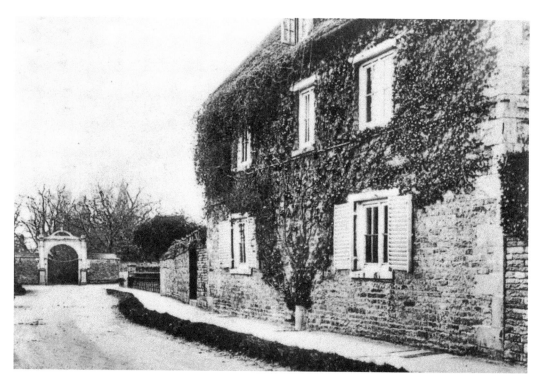

North Luffenham

This is the view towards the gatehouse and the arched entrance to the old hall. A former rector of this village, Archdeacon Robert Johnson (1540-1625) founded both Oakham and Uppingham schools. The former RAF base to the north of the village is now occupied by the British Army and has been renamed St George's Barracks.

Heywoods, Oakham School

Oakham School was founded in 1584 by a Puritanically minded Archdeacon, Robert Johnson. Over its long history, the prestigious school has weathered many storms. In 1875, there were just four pupils in attendance. Haywoods is the most modern of Oakham's boarding houses. Purpose-built in 1989, it houses some sixty-eight boys aged between thirteen and seventeen.

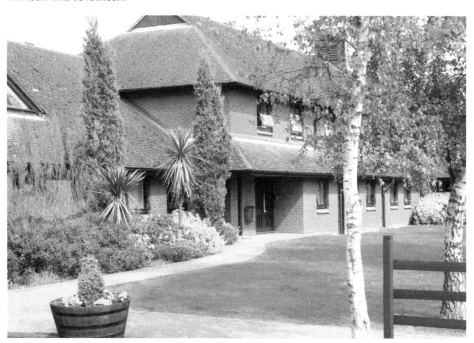

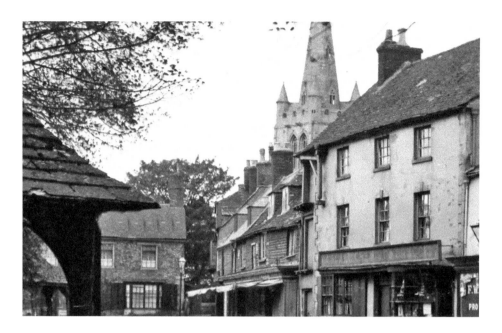

Market Place, Oakham

This photograph of the Market Place was taken in 1928. Oakham is a classic English market town. Many towns have tidied their market away into purpose-built market halls, but happily, a regular outdoor market is still held here every Wednesday and Saturday, and from dawn to dusk it is a bustling corner of the town. Oakham's famous octagonal buttercross is to the left of this view.

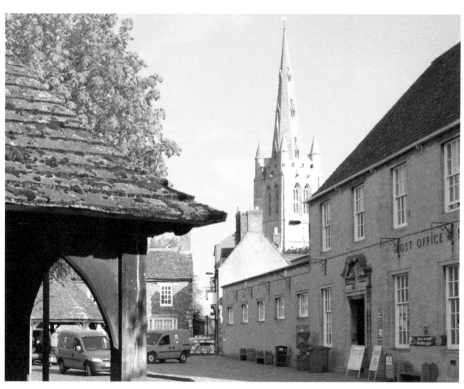

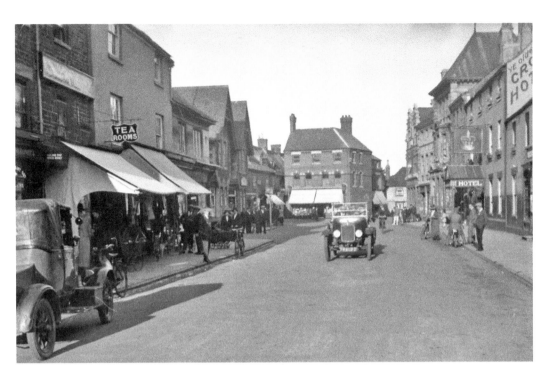

High Street, Oakham

Appropriately for a county town, Oakham's High Street is always busy. All the elements of a High Street are here. The Crown Hotel is now Crown House, but it has survived without major changes to its integrity. In 1974, Oakham lost its status as a county town but regained the distinction when Rutland became a unitary authority in 1997.

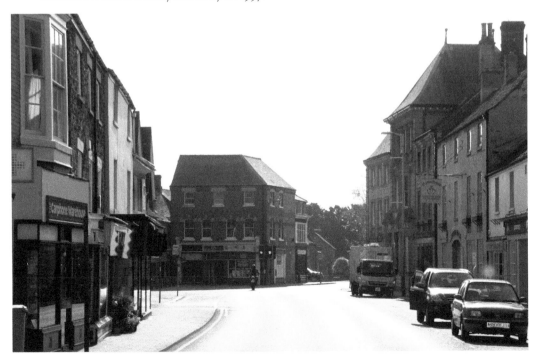

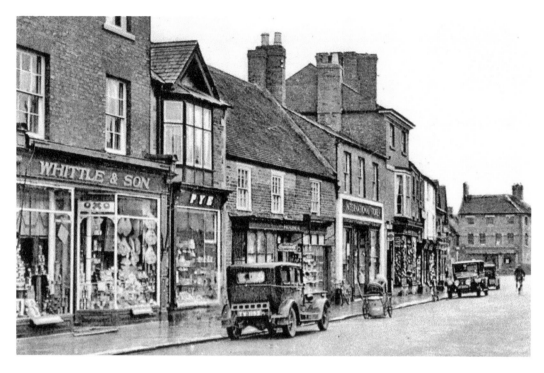

High Street, Oakham

In many towns, the high street is one of the first areas to suffer from haphazard and ill-considered redevelopment as buildings change hands and are altered to suit fleeting tastes and trends. But here in Oakham, despite the twenty-first century retail names, the old character of the town remains in evidence.

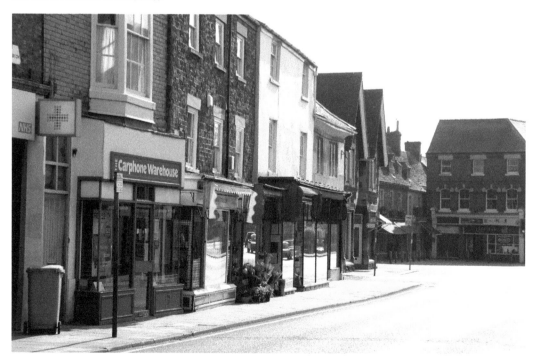

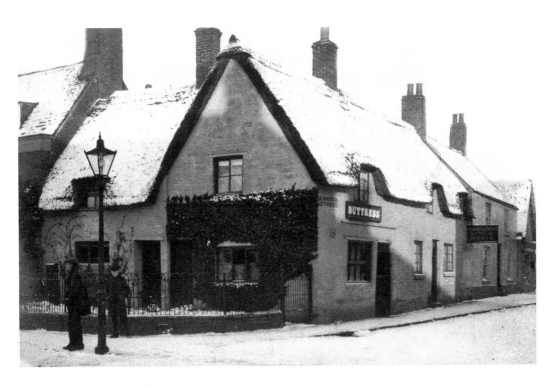

Church Street, Oakham

Sadly, Church Street seems to have suffered more from clumsy redevelopment and neglect than other areas of the town. There are very few thatched buildings in evidence today. This example is dominated by the unsympathetic development that surrounds it.

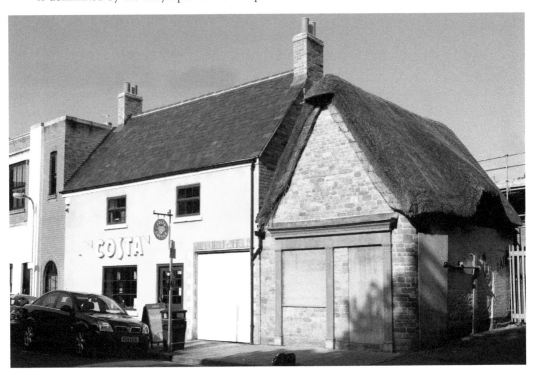

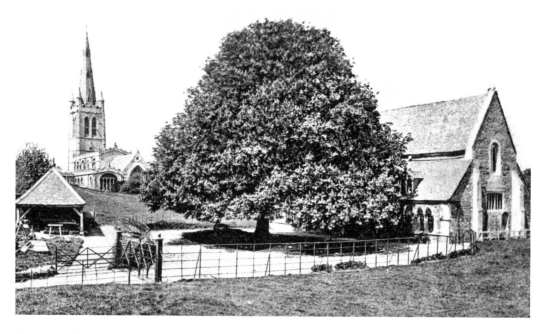

Church and Castle, Oakham

The church and the castle together give Oakham a strong and distinctive sense of history and heritage. It is the earliest hall of any English castle still standing, dating to about 1180-90, and the outer bailey is still evident in the surrounding landscape. The impressive spire of All Saints' Church can be seen for several miles. The church was restored by Sir Gilbert Scott in the late nineteenth century.

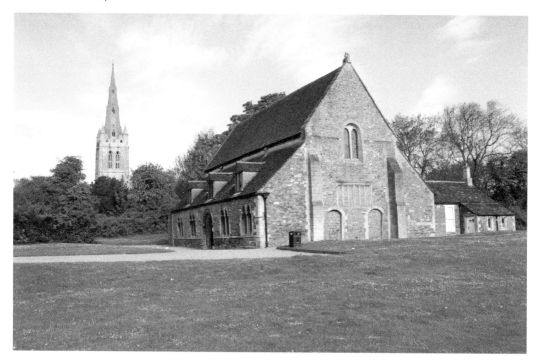

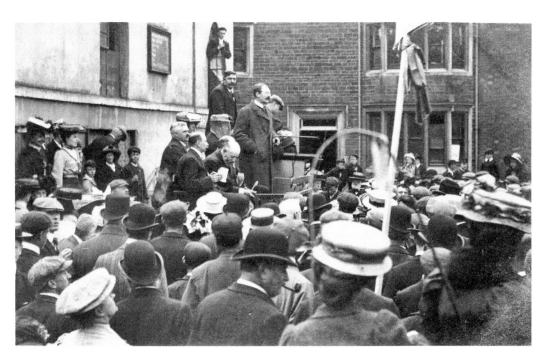

Poll Declaration, Oakham

The results of an election are declared in public, and the people of Oakham gather to see democracy being carried out. Close by are the buildings where people have traditionally gathered to exchange news, and where justice has been delivered – the inns, the castle, the church, and the old school.

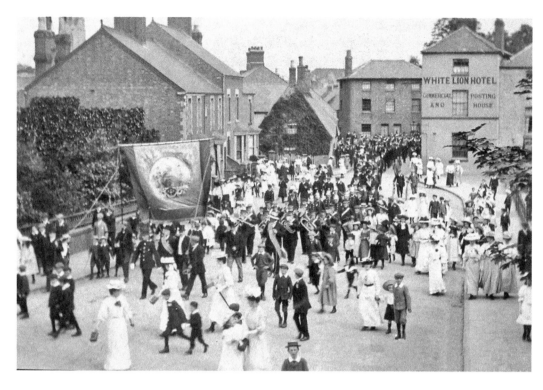

Hospital Sunday, Oakham
The High Street was also a place for parades, on this occasion to mark Hospital Sunday. The
White Lion Hotel dominates the area.

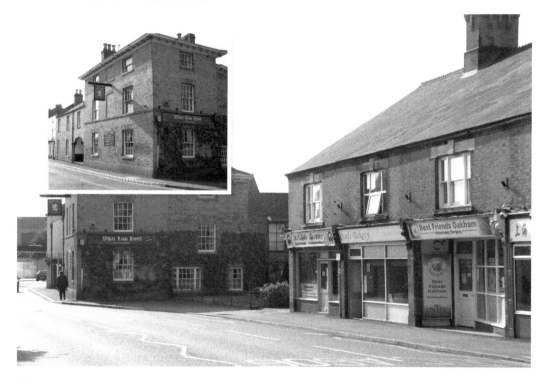

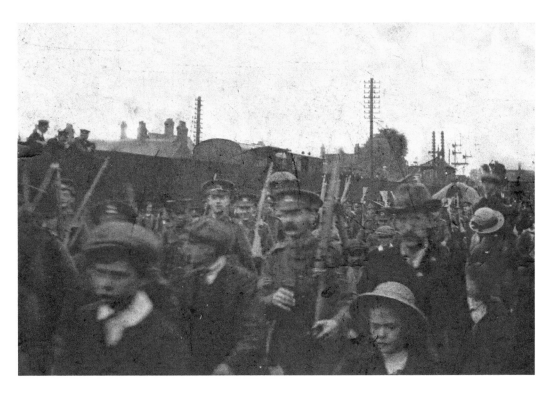

The War in Oakham

This indistinct photograph is one of great significance. The railways took the young men of England to war. From Wilfred Owen's 'The Send-Off': 'Down the close, darkening lanes they sang their way / To the siding-shed, / And lined the train with faces grimly gay. // Their breasts were stuck all white with wreath and spray / As men's are, dead.'

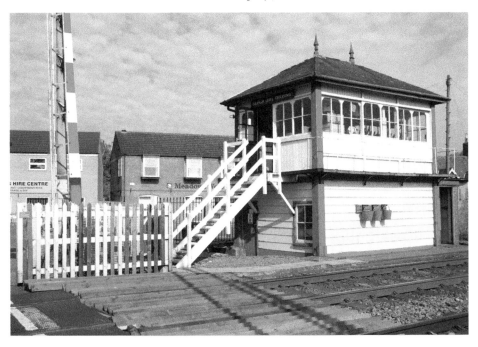

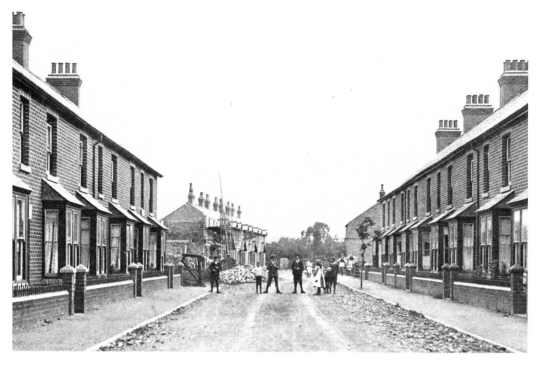

King's Road, Oakham

These are formal, dignified, typically quiet residential terraced houses, just away from the older and busier centre of Oakham. Demolition is in progress in the distance, and the local children have gathered to watch, but there is a palpable sense of another story, one the photographer is not able to reveal.

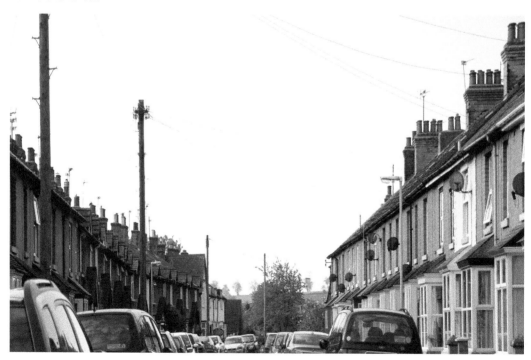

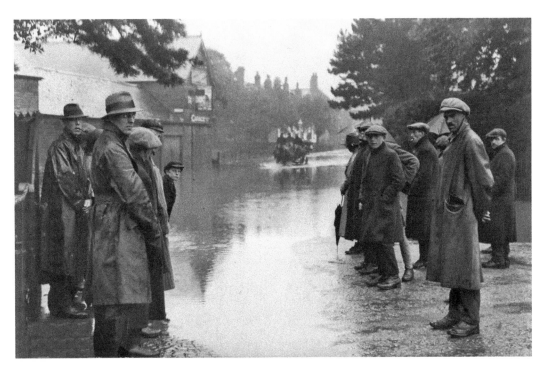

Cold Overton Road, Oakham

Until recent times, flooding was a significant and regular problem in many towns. This is the view out of Oakham along Cold Overton Road in 1925. The expressions on the faces of the residents speak of real misery.

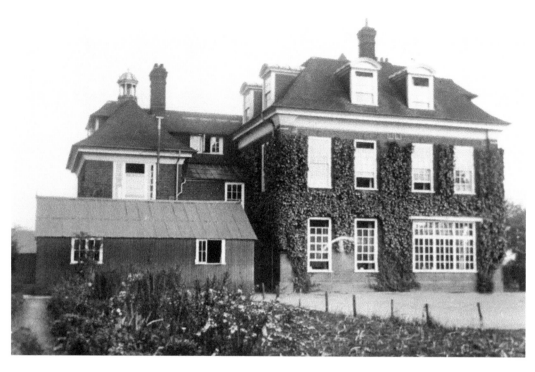

Chapmans, Oakham School

Named after an English cricketer, Chapmans was originally Oakham School's junior house. It now provides accommodation for around sixty students.

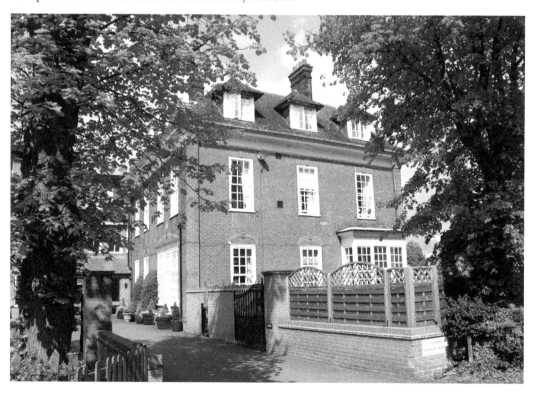

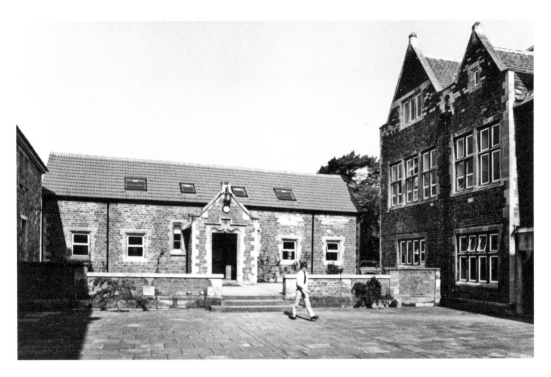

House, Quad, and Littles, Oakham School
Over the years there have been considerable and necessary changes to the older campus of
Oakham School.

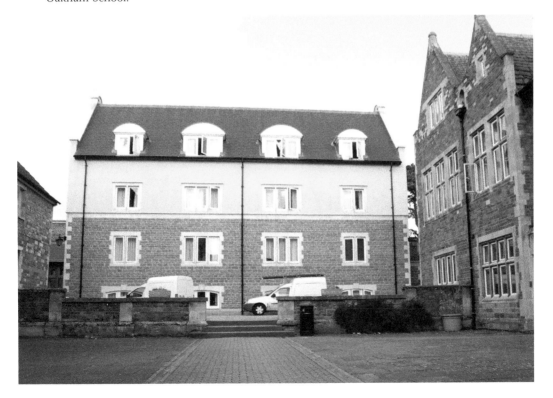

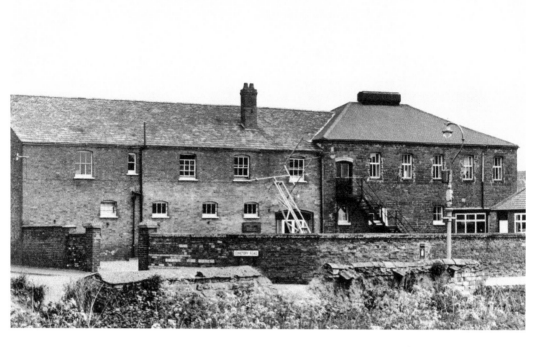

The Richard Bull Centre, Oakham School
The studios in the Richard Bull Centre, off Kilburn Road, house the art and design department of Oakham School. The metal sculptures in front of the centre were created by the Kenyan artist Wanjohi Nyamu.

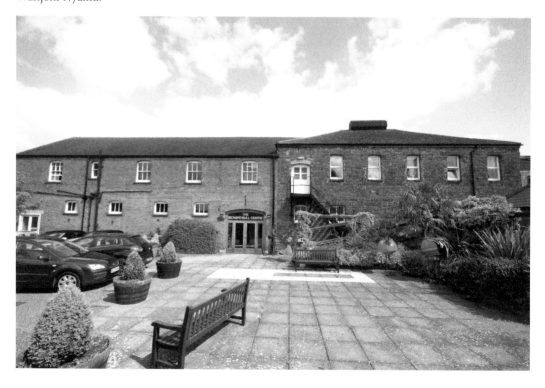

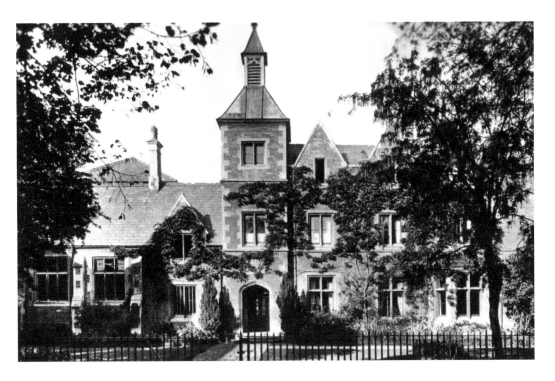

Oakham School House

Being so close to the heart of their community must add a lot to the experience of the students. Today, the school is still at the centre of the town, occupying buildings that date from almost every phase of its long history.

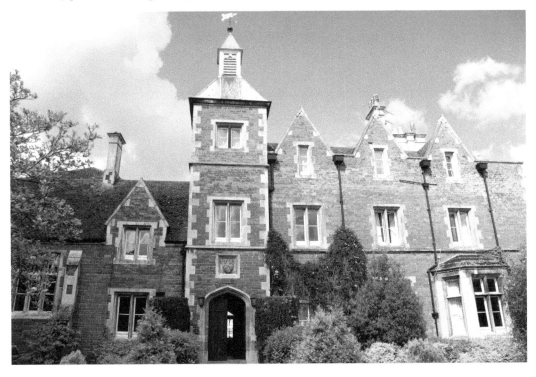

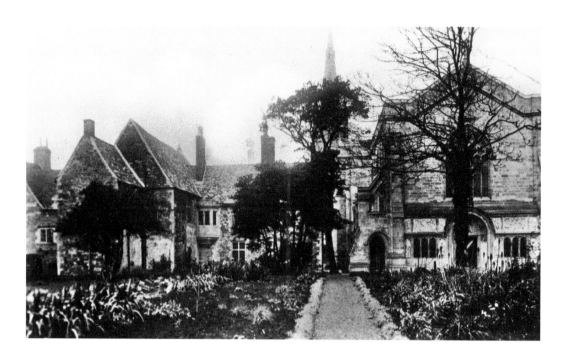

Memorial Chapel and Sanatorium, Oakham School
An act of worship takes place every day in the school's Memorial Chapel. The chapel was built in 1925 in memory of the sixty-nine old boys who died in the First World War.

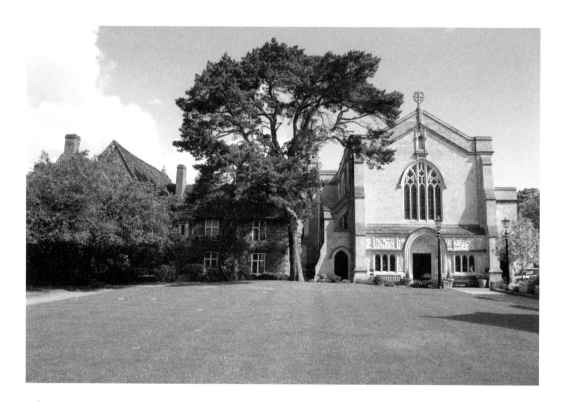

Strictly speaking, this view of Pickwell Church and Home Farm Lodge is of Leicestershire, but Rutland's landscape dominates Pickwell's horizon. There was a priest, and presumably a church, in Pickwell at the time of the Domesday Book. The north arcade of the present church dates from the thirteenth century, but the building was extensively restored in the nineteenth.

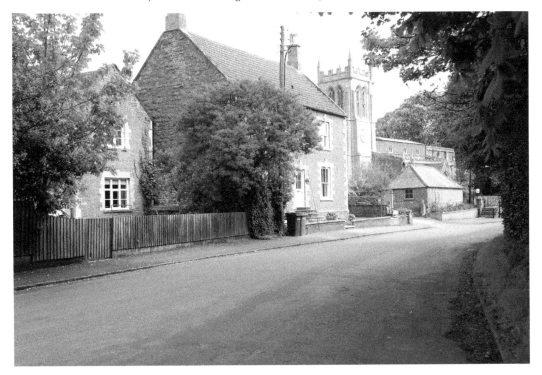

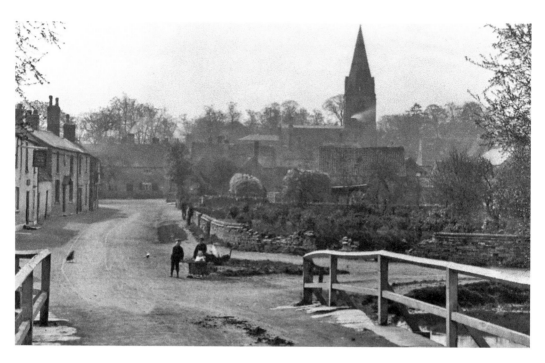

Ryhall

The river, the bridge that marks the approach to the old village, the pub, and the church create a delightful picture. Modern development has spilled out over the river and along the Essendine road, making Ryhall one of the largest villages in the county.

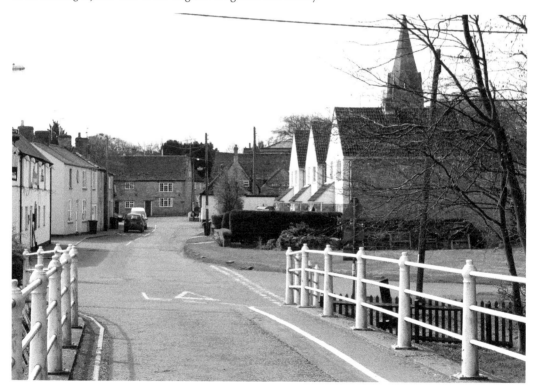

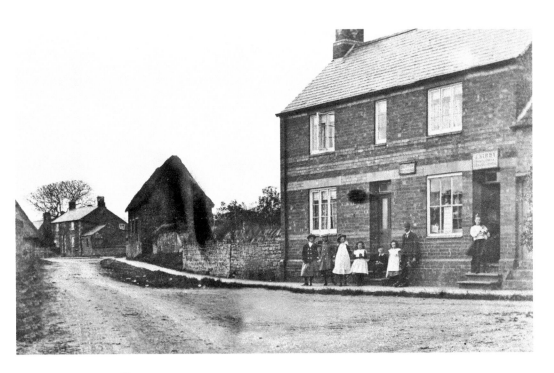

Seaton Post Office

There was a post office in Seaton in 1870, according to John Marious Wilson's *Imperial Gazeteer of England and Wales*. The building has been carefully and sensitively converted into a house. Older residents of the village remember shopping here. The sign above the doorway proclaims J. Kirby as a dealer in offal, and the poster in the window is announcing a concert and dance.

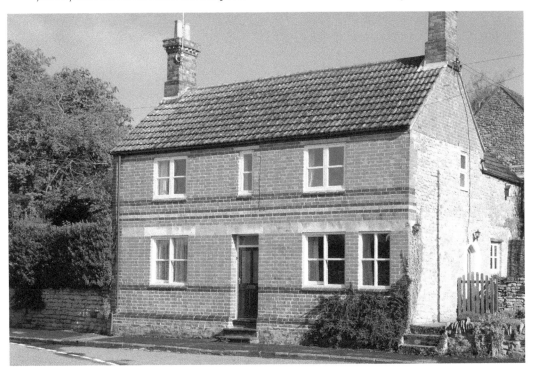

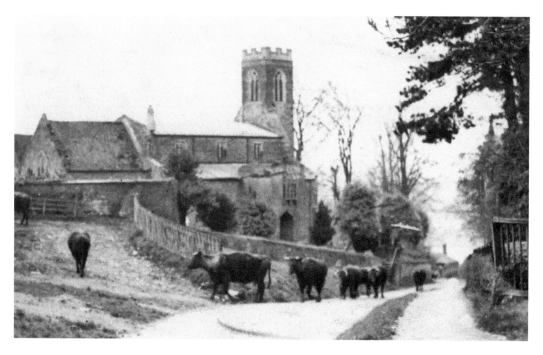

Stoke Dry

The farm by the side of the church is still there. 'Stoke' may derive from the Saxon word *stokken*, meaning a farm or a holding. There are just fourteen houses in Stoke Dry, all on the hillside that now overlooks Eyebrook reservoir. The murals in the church date to 1280-84 and show figures resembling Red Indians, which some claim supports the theory that North America was known at least 200 years before it was discovered by Christopher Columbus.

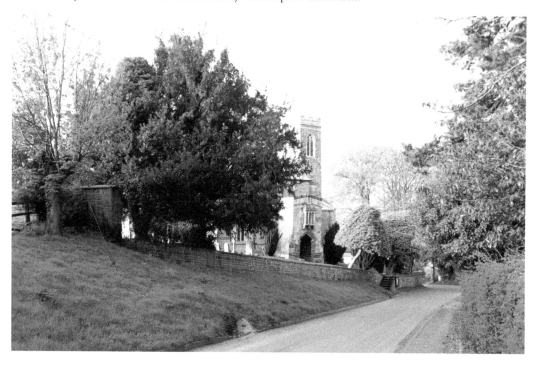

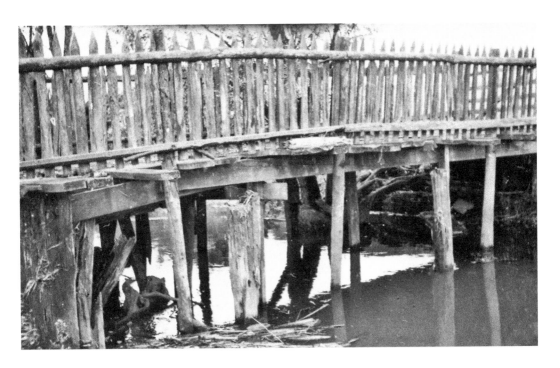

Black Bridge, Thorpe by Water

Historically, this hamlet has always been associated with the nearby village of Seaton. The earliest houses date to the seventeenth century. They nestle by the side of the River Welland, which marks the boundary between Rutland and Northamptonshire. This is a quiet, secluded settlement where farming is still predominant.

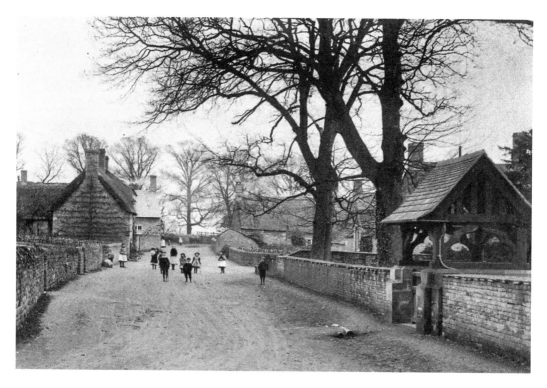

Tickencote

Spring blossom shades the lych gate of St Peter's Church, Tickencote. One former resident of the village remembers 'tug o' war across the ford' and 'fishing in the lane's garden and summer fêtes [and] freezing in the church with sermons from Reverend Page'.

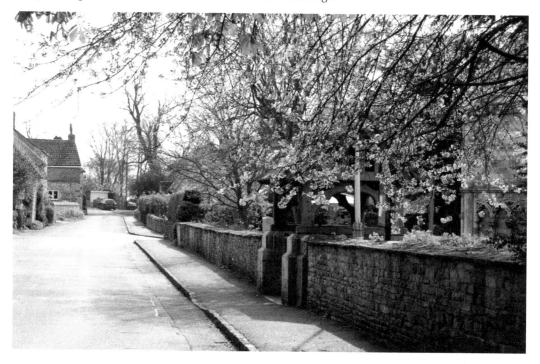

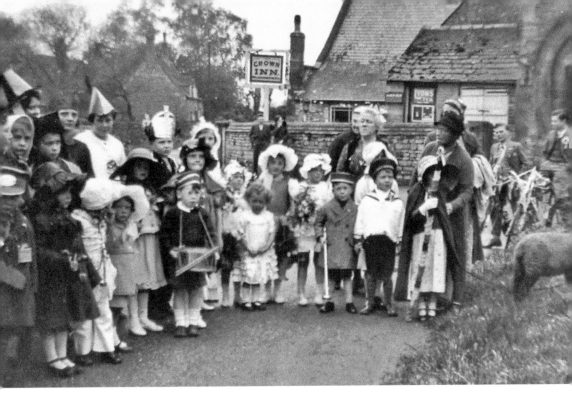

Coronation Celebrations, Tinwell

This early photograph dates from the 1930s, so these children and their teachers are probably celebrating the Coronation of George VI. Estate workers on their bicycles are observing the scene outside the Crown Inn.

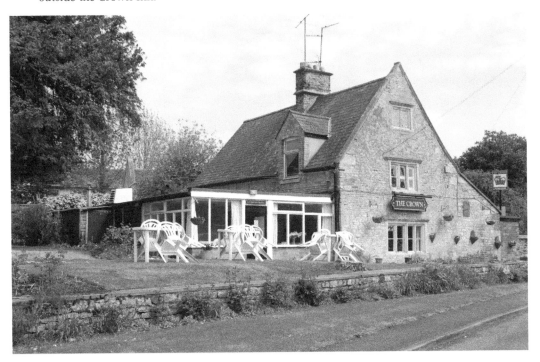

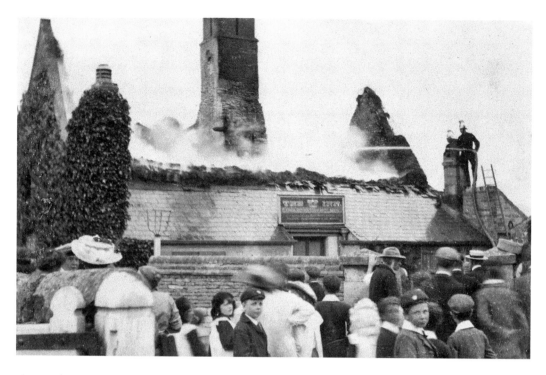

Fire at The Crown Inn, Tinwell

Tinwell is situated by the side of the Great North Road, but it is a quiet village. It is still closely associated with the Burley estate. A fire devastated the Crown Inn in the 1930s, but the pub was rebuilt and survives today.

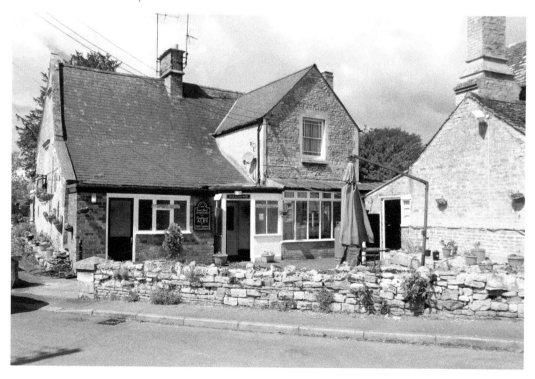

Drinking Fountain, Uppingham
Town drinking fountains were
commonplace and in use until the 1960s.
They no doubt developed from village
pumps and springs. These served, especially
in the villages, as place for meeting and
exchanging local news and gossip. The
fountain in Uppingham still stands in the
marketplace.

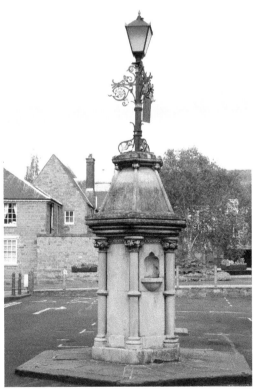

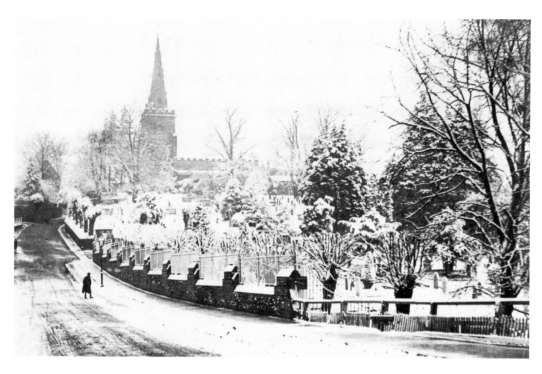

St Peter's Church, Uppingham

A cold but picturesque scene. Snow meant a long struggle up the hill towards the town centre. Dominating the approach to the town is the spire of St Peter's Church. The lush growth of the trees and hedges now obscure much of the church.

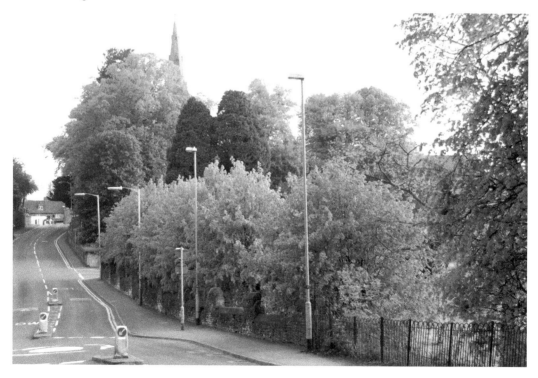

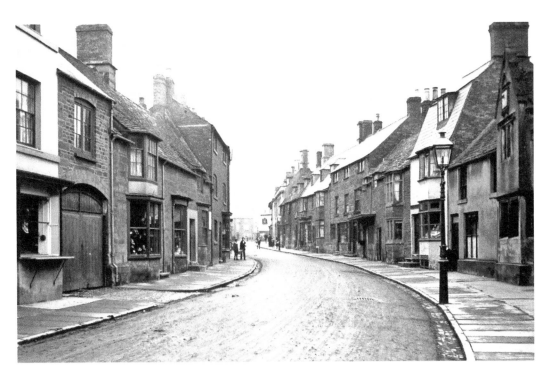

High Street, Uppingham

The broad sweep of Uppingham High Street before the age of motor vehicles. The many different styles of frontages and roof lines give the street a pleasant look.

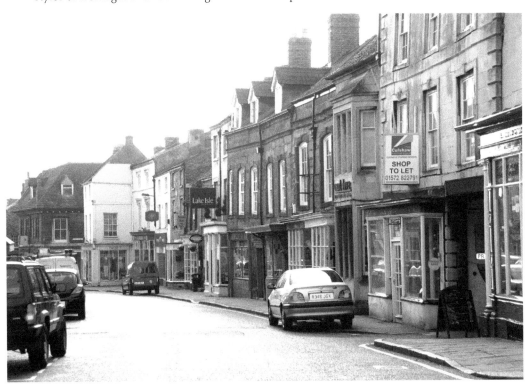

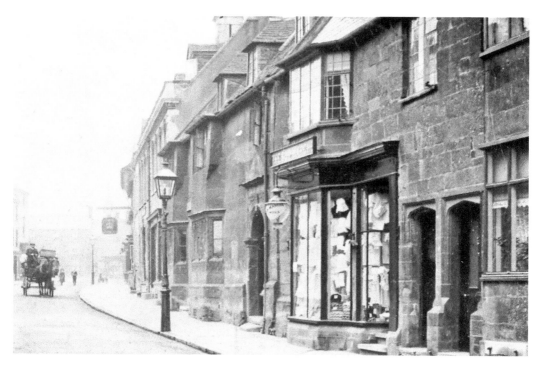

Bon Marché, Uppingham

The Bon Marché shop sold millinery, wools, and haberdashery on Uppingham's High Street. Today, the shop is still occupied by a local company, selling kitchens and kitchenware. It is pleasing to note that the early shop windows and frontage have been retained.

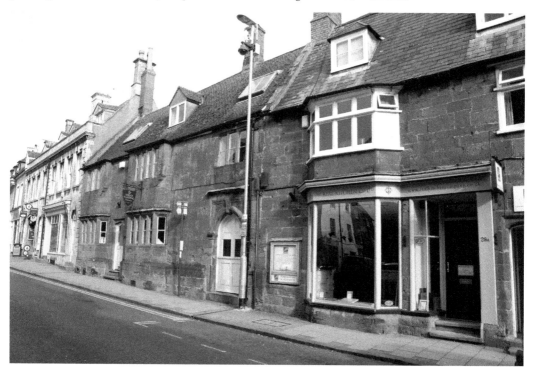

High Street West, Uppingham

This street was also a residential area with some of the most high-status houses in the town. A small thatched cottage hides between taller, grander homes.

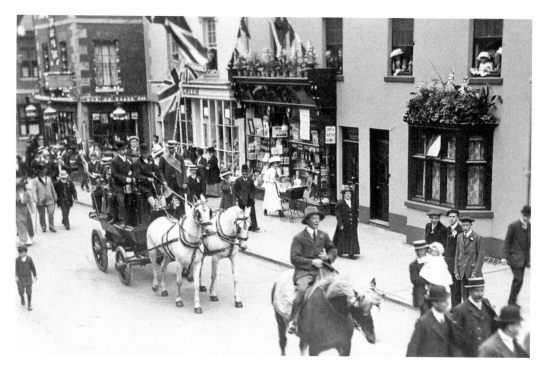

Uppingham's First Fire Engine

When Uppingham gained its first fire engine, it seems the entire town turned out to celebrate. Shopkeepers, maids, young children, and passers-by watched the local dignitaries proceed along the High Street.

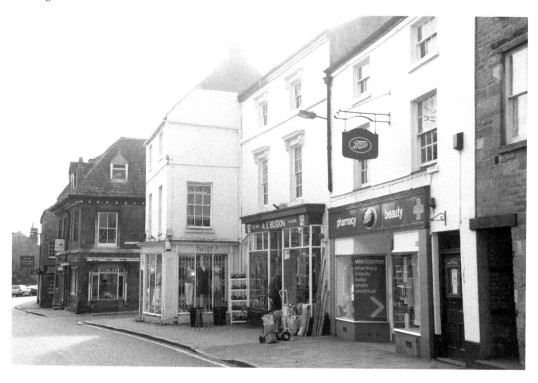

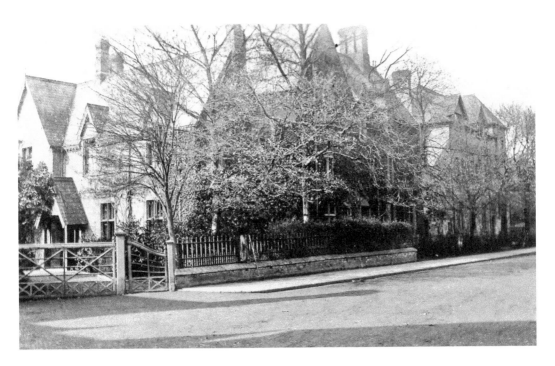

West Bank, Uppingham

Standing on the Stockerston Road are West Bank and its companion West Deyne, two of Uppingham School's boarding houses. The English and Classics scholar Jeff Abbot, who died in 2008, was housemaster at West Bank and created 'the Dell', the house's remarkable garden, in which he would hold classes whenever the weather permitted.

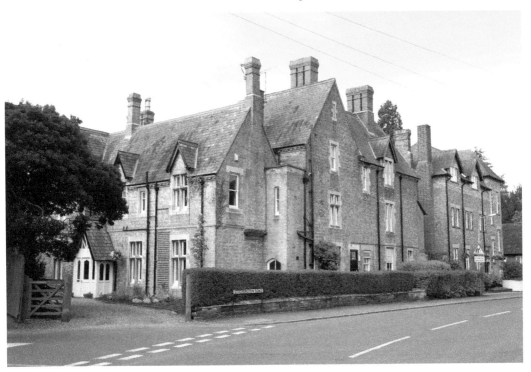

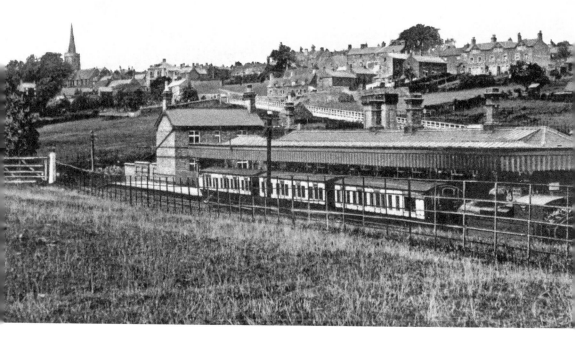

Uppingham Railway Station

This is another sad reminder of how England's heritage of picturesque railway buildings have largely been neglected. Replacing this charming set of buildings, which dated from 1894, is a conglomeration of industrial units that have no redeeming qualities.

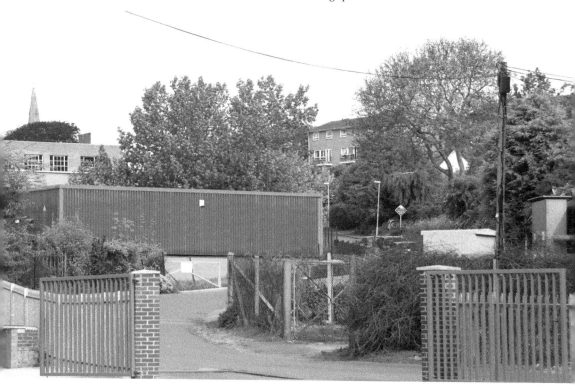

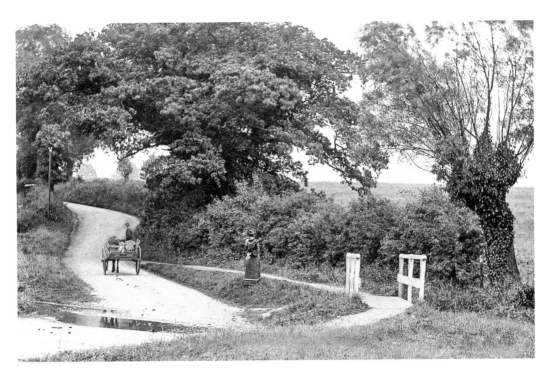

Wardley Hill in 1904

Until recently, Wardley Hill was potentially impassable after a snowfall. A new two-mile carriageway was opened in 1987 and the narrow road through the village is now a dead end. The village has no mains water supply; instead, water is supplied from a local borehole.

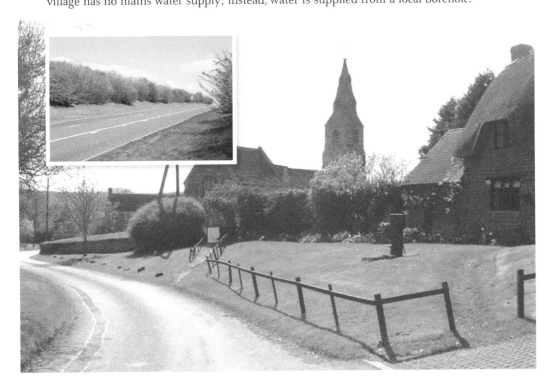

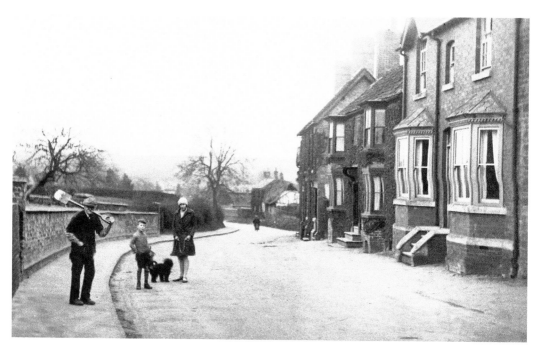

Whissendine

Whissendine is a village of different eras and styles. The oldest buildings are in the centre, nestling beside the brook. The pasture, called The Banks, is still let according to an ancient custom. A candle, in which a pin is stuck, is lit – and the last bidder before the pin falls is entitled to rent the land for the next year.

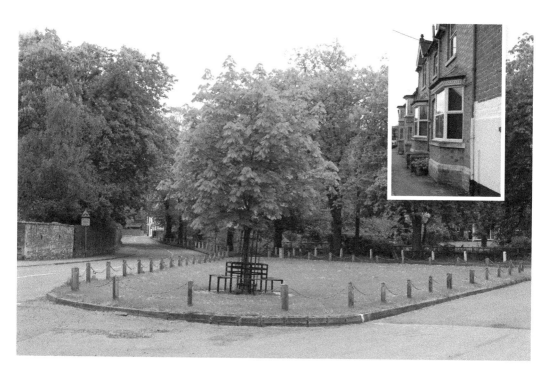

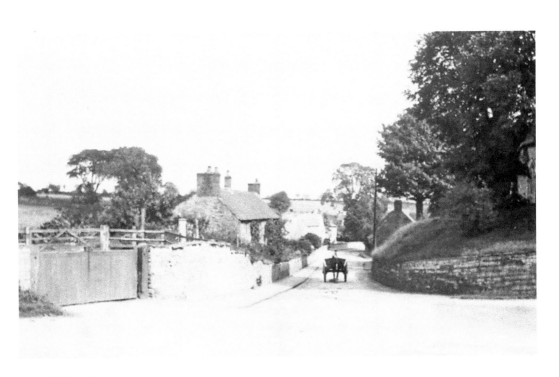

Whitwell

Whitwell is named after the spring that flows from beneath the church, called 'the white spring' or 'the white well'. During the building of Rutland Water, a Roman farmstead was discovered here complete with an iron-smelting hearth and furnace. The remains now lie beneath one of the reservoir's car parks. Just over one hundred years separate these two views. The road is now the A606, which links Oakham and Stamford.

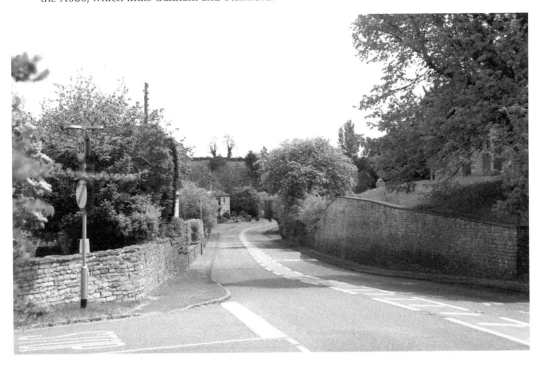

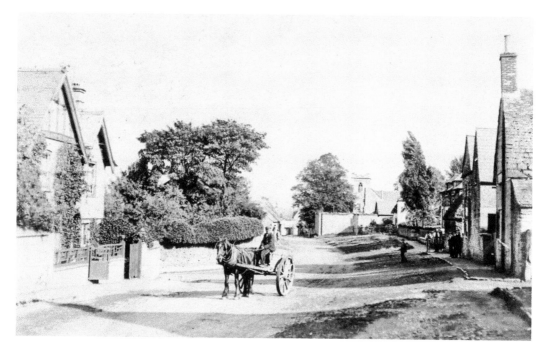

Wing

The oldest cottages in Wing were built with stone quarried at nearby Barnack. Some are roofed with tiles from Collyweston. The parish church of St Peter and St Paul had a spire until 1875, when it was removed during renovation work. Nearby, on the village green, is the famous turf-cut Wing Maze, which is circular and measures about forty feet in diameter. It is said to date from medieval times.

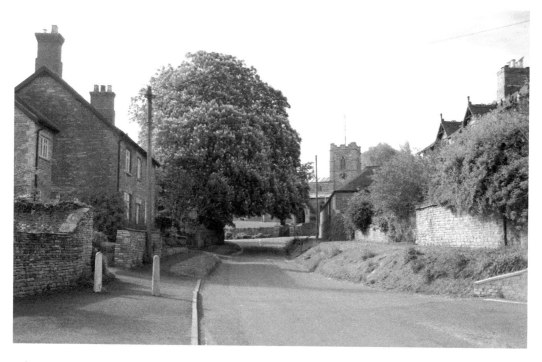